DIGITAL PHOTOGRAPHY EXPERT

Portrait
Photography

DIGITAL PHOTOGRAPHY EXPERT

Portrait
Photography

MICHAEL FREEMAN

LARK BOOKS
A Division of Sterling Publishing Co., Inc.
New York

Digital Photography Expert: Portrait Photography
10 9 8 7 6 5 4 3 2 1

Published by Lark Books, a division of
Sterling Publishing Co., Inc.
387 Park Avenue South, New York, N.Y. 10016

Text © The Ilex Press Limited 2004
Images © Michael Freeman

This book was conceived, designed,
and produced by:
The Ilex Press Limited,
Cambridge,
England

Distributed in Canada by Sterling Publishing,
c/o Canadian Manda Group,
One Atlantic Ave., Suite 105
Toronto, Ontario, Canada M6K 3E7
All rights reserved

Library of Congress Cataloging-in-Publication Data
Freeman, Michael, 1945-
Digital photography expert: portrait photography
 /Michael Freeman.–1st ed.
 p. cm.
 ISBN 1-57990-527-7 (pbk.)
 1. Portrait photography. 2. Photography–Digital techniques.
 I.Title.

TR680.F719 2003
778.9'2–dc21
 2003007922

If you have questions or comments about this book, please contact:
Lark Books
67 Broadway
Asheville, NC 28801
(828) 253-0467

Printed in Hong Kong

Contents

Introduction

Photography's classic subject is ourselves. Since its invention, the camera has been aimed at people more than at any other subject by far. As a species, apart from being highly self-regarding, we have an endless appetite for seeing what other people look like, what they are doing, what we look like. Every portrait photograph ever taken, even the poorest snapshot, is or was fascinating to someone. Add skill and imagination, factor in the capabilities of new digital cameras, and you have the potential for memorable, striking images.

The title of this book is "Portrait Photography," but I'm using it in a deliberately varied way, because I want to include much more than just a gallery of faces looking out at the viewer. What defines a portrait? At the least, a likeness of a person, most conventionally of the face. This seems straightforward, but if "likeness" means only that someone else would recognize that person from the picture, we could as easily rely on security cameras. No, the real concern of portraitists, whether painters, sculptors, or photographers, has always been to reveal the nature of people, to show something that they, the artist, has spotted within their subject. There are many layers of subtlety possible here.

Just compare the royal portraits of Hans Holbein from the sixteenth century with contemporary paintings by Lucian Freud. Both are widely considered the greatest portraitists of their time, and both are figurative, sharing many of the same concerns, not least being able to penetrate the character of the sitter. And yet the techniques and styles are poles apart, from meticulous miniaturist to a broad handling of paint that made flesh almost palpable. In photography, too, the definition has changed over the years, and has come to include scenes from the subjects' lives and activities.

To begin with, what most people want from a portrait—either as the subject or when using a camera—is to be recognizable, to look as attractive as possible, and to show the better side of one's personality. In other words, a sympathetic view that captures not just the physical likeness but something of the character. Simplicity is the catchword. The human face is interesting enough without complicated technique or unusual composition. If you catch the right expression, that alone can make the picture successful.

One of the keys to achieving this artless simplicity is being able to encourage people to relax and act normally—not to clam up in a stiff pose, but not to put on an act, either. Photographic technique apart, the most valuable skill you can acquire is to put people at their ease and lose their self-consciousness. A portrait does not have to be shot in controlled conditions with refined lighting, or even planned. Many of the best are impromptu—taken on the spur of the moment because the photographer seized the opportunity. And with a digital camera, there is no reason for hesitation—there is nothing to be lost, not even the cost of film.

People **Posed**

When we think of a portrait, this is what we normally have in mind—the sitter, positioned and lit, looking out through the camera's lens to the viewer. It is a kind of statement in which the person being photographed is saying, "This is who I am, and this is what I look like." It is deliberate and considered, and stands in a long line of tradition from the earliest portrait painting. And yes, in fact, photographers are the heirs to classical portrait painters whenever they undertake this kind of image.

Underlying such portraits is an arrangement between the sitter and the photographer. As we will see, there are other, more fluid and less formal ways of arriving at the same end, but in the case of a planned and posed likeness, the two of you are in some sort of agreement to make it work. The subject, by agreeing to be photographed, is complicit in all of this, though not necessarily compliant. There may, of course, be a commercial side to the arrangement, in which you are being paid for your skill in making what the sitter will consider to be a "good" photograph.

In this context, "likeness" is an apposite term. Almost without exception, a key aim of portraiture is that the end result should look "like" the person portrayed. The complication arises when it comes to who will decide this. The sitter's aims are always positive; they want to look at their best. There are different ways of detailing this, according to their self-perception. It may mean physical attractiveness, or social status, or power, for example. There is usually an element of idealization. Indeed, there may be an ulterior purpose. For a company's annual report, a board director will want to appear serious, solid, and capable. An actor may want to look suitable for the next role that he or she is after. A politician will try to project an image that will appeal to the key bloc of voters—whoever they are at the time.

The photographer may have different ideas. Even if you agree with your subject on the desired effect, you may, by being more objective, think of a different way of achieving this. The sitter is unlikely to know many of the techniques described in this book, and for this reason you, not they, will need to take control of the session—in the nicest way, of course. And you may, as often happens in newspaper and magazine photography, want to present another aspect of your subject. This does not necessarily mean an adversarial approach, showing them in a deliberately unsympathetic light (although this has happened, particularly with photographers who have large egos to feed). It may simply be that you want to make an editorial point—showing the person in relation to something that makes them newsworthy. In addition to all of this, most photographers enjoy exercising their visual imagination; we like to make images that are interesting, original, and satisfying to look at.

In any case, this kind of portrait is prearranged, whether a few minutes or a few days in advance. And it is you, the photographer, who will have to make the arrangements and assure that they are geared toward a successful final image. You are the director, and your skills at dealing with people will be called upon. In the following pages we look at ideas and techniques to help.

Capturing expression

Whether animated, relaxed, or enigmatic, this is what brings a portrait alive for the camera, and the photographer's two tasks are to encourage it and capture it.

If you asked one hundred photographers, "Which single element is the most important in a portrait?," you would probably get the answer "the eyes" one hundred times. Expression, however, is more than just the eyes; it is the interplay of all the features of the face filtered through the angle at which you view it. From an early age all human beings learn to read the facial expressions of others and good photographers develop the ability not only to read expression, but to encourage particular expressions in others.

Some photographers know what expression they want from their subject and work hard to encourage it, while others prefer to watch and capture a naturally occurring expression. Both methods are perfectly valid and both rely on the photographer establishing a rapport with the subject (*see box*). Time spent getting the trust of your subject will be repaid with interest when you start shooting.

Even without a camera in your hands, you can study other photographers' pictures as well as people's faces and work out which elements combine to give easily read expressions. Mastering the subtlety of expression is a life's work, but employing what we all know from childhood about the messages a face can give you delivers a big advantage.

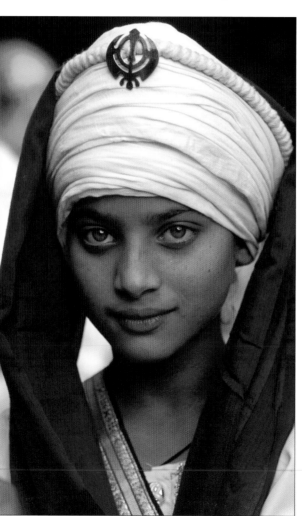

▷ **Sikh girl**
A young Sikh girl in an annual procession in Amritsar, capital of the Punjab and home to the Golden Temple. Her pale green eyes were the most striking feature, added to the rich blue turban, clear complexion, and a calm, direct gaze straight to the camera. No embarrassment, no self-consciousness; an on-the-spot portrait I was glad not to have missed.

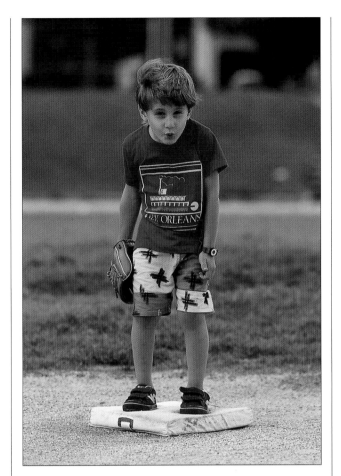

Rapport

Establishing a rapport with your subject begins from the instant that you first have contact. If the person is a friend or relative, then make use of your existing relationship. The majority of portraits are made between strangers, so it is up to the photographer to establish a relationship that inspires trust. The combination of an easy, confident manner with some simple uncontentious topics of conversation is the easiest way. There are photographers who specialize in confrontation and others who use flirtation, but the use of an approach that deviates from the amiable will always be a big risk. The importance of the interaction between the photographer and subject cannot be overstated. You need to be able to communicate with each other by talking, making gestures, or even through eye contact in order to increase the probability of a good expression. Eye contact is not at all easy to maintain when you are constantly looking through a camera, so it is important to keep the communication between you and your subject alive through conversation and gesture. It is equally important to use eye contact whenever you aren't looking through the lens, just as you would if you were having a normal conversation. One of the uses of a tripod is that, once the shot is framed, you can talk directly to the sitter without having to look through the viewfinder.

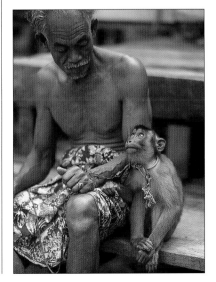

Macaque and owner

During a pause in shooting a magazine assignment about monkeys trained to collect coconuts on the east coast of the Malay peninsula, one of the young macaques climbed up to sit next to the plantation owner. The glance exchanged between the two was momentary, but hard to read as anything other than a close affection, even though the monkey was a co-worker rather than a pet.

Catcher

The expression that makes the shot in this picture of a baseball game in a Toronto park is the sheer frustration of the catcher as the player takes off for a home run.

Pathan man

I was photographing a series of portraits of Pathan tribesmen after prayers in Pakistan's Northwest Frontier Province. I asked each man to look straight at the camera for a simply posed image. Pathan men possess a certain warrior vanity, this one in particular. He raised and turned his head slightly; I was impressed by the haughty expression and made the most of it.

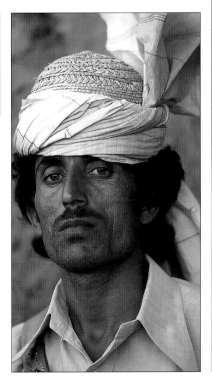

Planning

A portrait session is one kind of live performance, and as with any staged event, the behind-the-scenes preparations can go a long way to guaranteeing its success.

A phrase used in all sorts of fields is "precise and proper planning prevents poor performance." Portrait photographers more than most need to adopt this mantra. Another, familiar to photojournalists, is "who, when, where, what, and why." If you ask yourself these questions before you set out to shoot the pictures, you will have your planning to all intents sorted out.

Who? You will probably know the name, age, gender of your subject—and whether there is more than one person—and this will give you some ideas about what techniques you might use.

When? The time of day and the time of year will give you important clues about how much light there will be and which direction it will be coming from, and indeed whether you can rely on natural lighting. It might point you toward a particular event—the answer to "When?" could be at a family event or after a soccer match.

Where? The location will dictate the lights you may want, or need, to use. It will also usually dictate the possible backgrounds, and these will have a strong influence on the type of picture that you take.

What? This might indicate an event or an activity. It might suggest a formally lit portrait or a relaxed, candid photograph.

Cornucopia

This cover shot for a book on Asian cuisine required a tropical beach shot with a cornucopia of Asian food. Fill-in light was tungsten with a blue gel, powered via extension leads from the hotel mains. Flies were inevitable, but by shooting at 1/15 second they disappeared from the image.

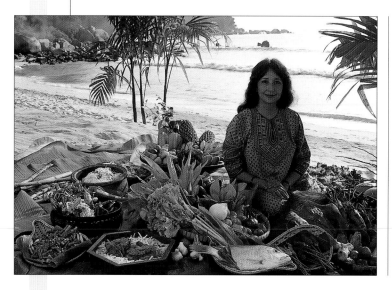

The importance of lists

It's always a good idea to make lists when you are shooting unfamiliar jobs. Here are a few samples:

☐ **Equipment list** Everything you need to do the job, which bag it's packed in, and a check that you have all the necessary batteries, fully charged.

☐ **Timetable** List every important stage in the event, an approximate start time, and probable duration.

☐ **Shot list** The various images that you need to shoot, ranging from those that are essential to those that are merely desirable.

☐ **People** Who's who, their phone numbers and addresses.

As you become more experienced, you will work out your own way of doing things and you will learn to rely on your own lists. Good planning means leaving as little to chance as possible, and having your plans on paper is always a good idea.

Why? The reason why you are taking the shot. Is it for a framed picture on somebody's wall, or is it for use in a magazine? The end use of the picture often directs the way you shoot it.

Five simple questions that all add up to the big one. How? This question decrees what sort of equipment you need to pack, and whether you can call on your experience of doing something similar before. It may be that you need to search for examples of the ways in which other photographers have tackled a similar subject, or should do some reconnaissance at the location. If there is a degree of uncertainty in your mind, make some test shots before attempting the session for real.

Once you have answered all of the questions, you are well underway with your planning. You need to consider what could possibly go wrong—for example, bad weather, late arrivals, equipment failure—and make contingency plans. Well-made and flexible plans let photographers concentrate on what they do best—making strong images.

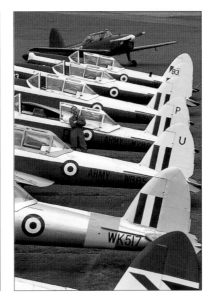

Flying club
The subject was a pilot at a club that had several of these old air force trainers. I also wanted to show as much as possible of the aircraft, so with a day's notice it was possible to arrange for most of them to be lined up to give this view from the control tower.

The office
This portrait session with Hong Kong entrepreneur David Tang was set up at short notice and there was little time available for planning. The circular window and eclectic decoration were obvious features, and the viewpoint was chosen with these in mind. The sitter was then placed, not behind his desk as normal, but in front.

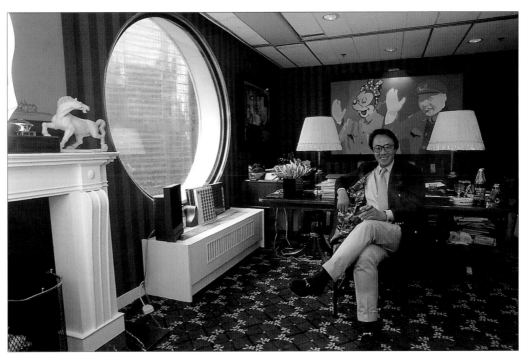

Setting the scene

The place where you choose to photograph your subject can be much more than a blank backdrop; it can be an active, even an interactive, part of the shot.

We opened this first section of the book with expression, which, when it is strong and definite, usually dominates a portrait; it immediately draws attention. But a portrait does not have to be restricted to depicting the face alone, or even the person alone. There are times when it makes sense to bring the location into the photograph, and even to let it play a leading role.

With the single exception of the "pure" studio portrait, in which the canvas is a blank backdrop for the sitter, and which we'll come to in detail later (*see pages 50-51*), all photographs of people take place in some definable setting. If these settings are interesting because of what they are or how they look, why not consider stepping back and making something of them?

Inevitably, this means reducing the size of the person in the frame, either by shooting from farther away or by making a wide-angle composition (about which, more on pages 82-83). In the examples here, the setting, once chosen, immediately began to take over the shot, both in preparation and in the picture area. This is no bad thing as a way of ringing the changes; portrait photography, as much as any other kind, benefits from variety and originality, and this is just one of a number of ways of achieving this.

Elevating the importance of the location requires more attention to be paid to setting it up. It may need to be dusted, cleaned, tidied, pared down, or even built up. Factor in extra time, effort, and the cost of making sure that the setting is up to scratch for the final shoot.

Chipmunk pilot

The subject of this portrait owned and flew a Chipmunk trainer, and was one of the main characters in a story for *Air and Space Magazine* about this old RAF aircraft. There were three other people, all pilots also, to be photographed for the same article, so each shot had to look different, while at the same time including aircraft. An in-flight cockpit shot was a natural, but needed to be arranged, and planned for interesting weather. The forecasts were watched for several days, and the shoot finally set for an afternoon with a mixture of sun and rain. The pilot flew from the rear seat, while I sat in the front and used a 20mm wide-angle lens to include as much of the setting as possible.

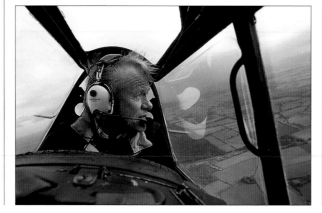

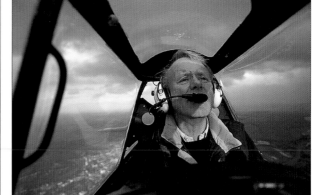

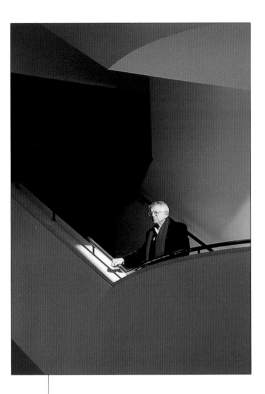

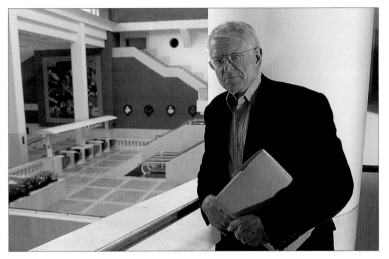

An architect and his work

An assignment to photograph the new British Library included a portrait of the architect, Sir Colin St John Wilson. It made sense to photograph him in context, and I explored three different types of shot, all taken within a few feet of each other. In one (left) I looked for part of the interior with strong graphic possibilities, keeping the figure relatively small. In a second approach (above), I used a wide-angle lens with the architect prominent in the foreground and a broad view of the interior in the background. In the third shot (below), I focussed solely on the architect, using the plain white of the staircase as an abstract setting.

Location checklist

☐ Does it need tidying? Look for scraps on the floor, anything obviously disordered, drawers left open, doors ajar, and so on.

☐ Do surfaces need to be cleaned? Look for films of dust (particularly noticeable at a shallow angle to the camera), marks on windows, and crumbs and fluff on the carpet.

☐ Are there unnecessarily distracting objects in view? Look for strong clashing colors, images (posters, photographs, paintings) and words (posters, book covers, signs). Do they add or detract?

☐ Are there any shiny or mirrored surfaces in view that will reflect you, the camera, equipment, lights, or anything else that is unwanted?

☐ Does the setting need props and dressing—in other words, to be treated almost as a film set? If so, what needs to be added, where can it be found, how long will this take, and how much will it cost to hire or buy? This may be making too big a thing of the photo session, but equally it may make all the difference.

☐ What additional lighting will it need? Can you manage without? Are there sufficient accessible power points?

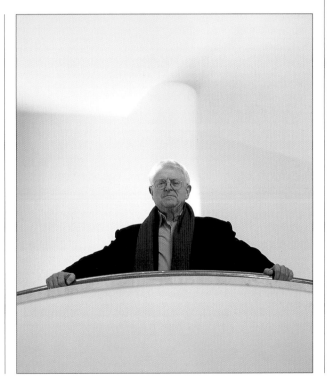

The contextual portrait

Pitched between documentary reportage and studio portrait, this supremely editorial approach links the subject to his or her life, work or activities.

One highly effective way of making a portrait, although it takes some preparation, is to set the person in the context of what they do—whether work, an interest, some characteristic location or unique activity. This approach, heavily used by magazines, attempts to cram more information than usual into the image, by telling a mini-story. The reason it is used so often

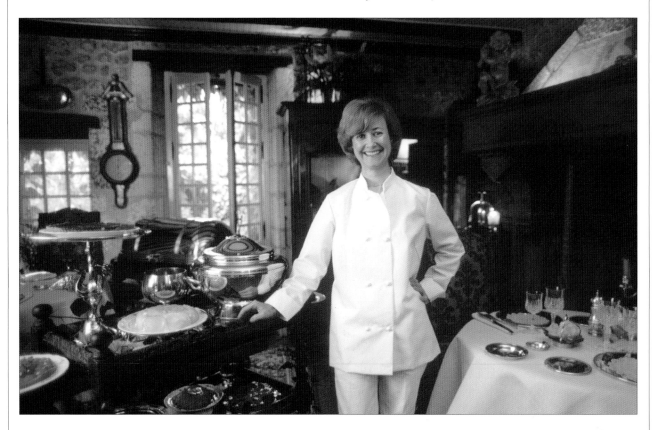

Chef

With an outgoing personality, this French chef at a famous restaurant in the Dordogne felt happiest in her restaurant. The photograph was taken in a couple of minutes before the lunchtime sitting. The added lighting was a single incandescent lamp, diffused with an umbrella and filtered half-blue to fit between the color balance of the daylight and the interior tungsten lights.

editorially is because this kind of picture usually accompanies an interview or an article which is focussed on some aspect of the person's life. In this sense it is a form of photo journalism.

The key is to decide on what the appropriate context is—the location and the props. It may all exist already, or it may be necessary to bring together a number of objects. In either case, be prepared to spend some time organizing the shot. There are no rules about lens focal length, but there is often an argument in favor of a wider angle, simply in order to gather together a number of things in the frame. If the props are small, a wide-angle lens will emphasize them if they are arranged in the foreground.

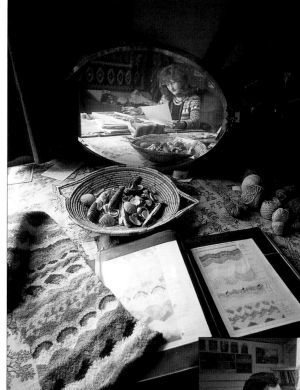

Natural designs

A working portrait of a textile designer who produced knitted designs inspired by natural, found objects, such as shells. A wide-angle lens (20mm efl) made it possible to include a large amount of the detail of her work, including sketches, yarn, and the shells. In order to combine all of these with the subject, I used a mirror to reduce her size in the image.

Painter's technique

This painter was the opposite in personality to the French chef, somewhat retiring, but relaxed when working. To emphasize one of the trademarks of his style—a meticulous attention to detail—the photograph was shot with a wide-angle lens close to a glass of wild flowers being painted. Natural daylight in the painter's studio was sufficient.

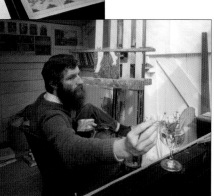

Improve your portrait

- ☐ **Lens** Use a telephoto for more flattering proportions, particularly if you close in on the face or head-and-shoulders. If you have only a wide-angle lens, step back and frame the subject in a setting.

- ☐ **Depth** For close shots, set the aperture wide—no smaller than two f-stops down from the maximum—to isolate the person from the background. Focus on the eyes.

- ☐ **Light** Diffuse the main light and place it slightly in front of the subject, overhead and slightly to one side. With a proper photographic light, an umbrella is the easiest diffuser to use, but soft daylight from a window also works well. Use a reflector (white card or aluminum baking foil) on the side of the face opposite the light.

- ☐ **Pose** There are no hard and fast rules, but when people lean forward slightly toward the camera, they usually look more interesting and alert. One fail-safe pose is to sit the person down with a surface to lean on, like a table, then shoot from a slight angle to the body with the head turned toward the camera.

- ☐ **Rapport** People generally photograph best when they are relaxed. To encourage this, keep the conversation going, and look as if you know what you are doing. If the expression starts to freeze, ask them to look away for a moment, and then back at the camera.

- ☐ **Frames** Shoot a lot. It costs nothing with a digital camera, and more than anything else helps to relax a nervous sitter, who doesn't feel the need so much to hold an expression.

Familiar surroundings

Photographing people on their own home ground helps them to relax and be themselves, and so eases the occasion, but you need to observe the protocol of a guest.

From the moment that you arrive, you have two potentially conflicting tasks—to take good photographs and to be a welcome visitor. With these in mind, one of the most useful tactics is to take an interest in your subject's home. Everybody responds to some form of flattery and this will help to relax your subject and get a conversation going. You might talk about a particular painting or the color of the carpets—it doesn't matter as long as you are engaged in conversation and your role as a photographer is taking second place to your role as a guest, while you both settle in.

Ideally, you will be given a choice of rooms to shoot in and most people will have a preference about where they are photographed. The chosen location must add to the atmosphere of the image and not dominate it. As a photographer there will nearly always be a legitimate technical reason why you might not choose a particular room, so don't be afraid to mention your objections on those purely technical grounds when you want to shoot in the sitting room rather than their favored study. Sometimes it's easier to shoot a selection in more than one room as well as the garden.

The room's lighting may affect your decision. Very few homes will have a great deal of ambient light unless you sit your subject by a window, and you will often need to supplement it with flash or other photographic lighting. This is covered in depth on pages 42-49, but make sure that you have enough of the right kinds of cables to power any light you want to use, and that you ask before removing one of your host's power connectors.

10 things to remember

- ☐ Make sure that the surroundings complement the subject. The aim is to show the person at home.
- ☐ Make sure that you have enough space for any lighting or reflectors.
- ☐ Ask your subject to have a quick look around to make sure that they are happy with how tidy (or untidy) the area you are shooting in is.
- ☐ Avoid sitting people in their favorite chair unless you are sure that they will not slouch and that their clothing will not look unflattering.
- ☐ Watch out for ornaments, lamps, and plants appearing to sprout from someone's head and shoulders. Homes tend to be far more cluttered than is ideal for photography.
- ☐ Never forget that you are in somebody's home, so be careful with your equipment and ask permission before shifting the ornaments or furniture around.
- ☐ Keep your subject away from walls, where shadows will limit your lighting options.
- ☐ Unless there is a compelling reason, avoid shooting from below or above. Use the same level as your subject.
- ☐ Check in the LCD screen for unwanted reflections in glass, metal, or other highly reflective surfaces.
- ☐ When you leave, do so as a guest.

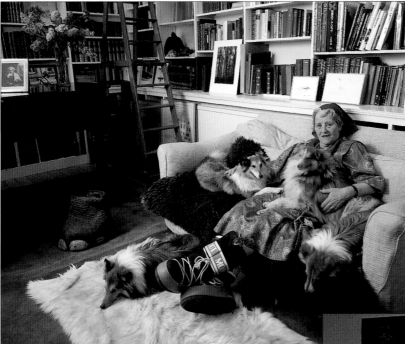

A naturalist at home
The renowned entomologist Dr Miriam Rothschild, who felt uncomfortable about a formal portrait (we had already done a number of working portraits with her at the microscope and with her study specimens). I persuaded her, still wearing her snow boots, to sit on the sofa with her dogs, and the attentions of these pets helped her to relax.

The perfume house
The proprietor of one of the most famous French perfume houses, a family business, also happened to have an exceptional talent for blending perfume—in the jargon of the business, he was a "nose." The obvious place to make his portrait was where he was most comfortable and happiest, in the laboratory, where he was delighted to explain and demonstrate the arcane techniques of the parfumier.

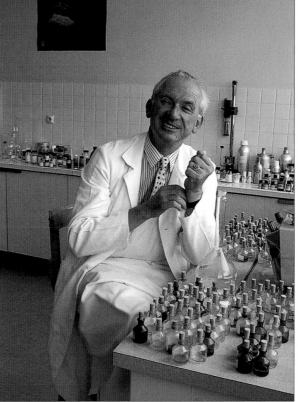

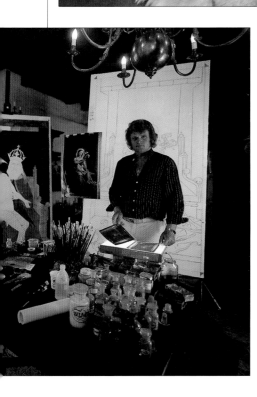

Art restorer
A German painter who specializes in the restoration, and sometimes complete copies, of damaged or lost works of art. The studio, in a south Bavarian village, was worth a shot in itself, and the painter was at his most relaxed explaining his procedures. A large canvas, bare except for a sketched outline, made an obvious backdrop.

Sequence and selection

Normal shooting procedure involves editing a sometimes lengthy sequence of frames; digital photography makes this more immediate.

It's the ability instantly to review the photographs that you've already taken, combined with the knowledge that shooting more doesn't cost you more, that makes the modern digital camera such a superb tool for photographing people.

There are three levels of photographer when it comes to getting the picture right. There are those who look at their pictures and have no idea where they could have done better. There are those who look at their work and can see where they went wrong so that they get better next time. Finally there are those who are lucky enough to get it right first time around. That third category is so small that it's best to concentrate on

File browser
Browsing software, either that supplied by the camera manufacturer or third-party, makes this kind of selection process very easy. Thumbnail size can be adjusted according to how many pictures you want to review, and individual images can be enlarged at a click.

being in the second group, and here the ability instantly to review everything gives a wonderful opportunity to make improvements as we progress through the shoot.

Don't confuse instant review with instant editing. Unless you need to create space on your memory card, it's always a good idea to keep the whole shoot so that you can examine the entire sequence on the computer later—and importantly how it progressed. Instant review should be used to help you correct problems with composition, light balance, and posing. Even if your LCD measures only 1½ inches (37.5mm), it will give you a great deal of feedback about these three critical elements of a portrait.

Shooting a portrait has a rhythm of its own and you will develop your own technique for consulting the LCD for that vital feedback. The session will probably not flow at all well if you check the screen between every single frame. At the beginning you should be checking very regularly and looking at the picture with a critical eye, and as you continue to work you could check every three or four frames, later every six or seven. If you change the lighting or move the subject around, then go through this process again. This kind of rhythm becomes as natural as focussing—and a feature that deters most digital photographers from ever going back to film!

There will have been a plan in your mind as you started to shoot, and there will come a stage when you have achieved that plan. It's at this point that digital comes into its own when, for no extra cost, you can start to experiment. Once you have the "safe" shot on your memory card, you can try a few ideas that may or may not work and you will be able to judge your progress instantly.

After the shoot, you need to review what you have done carefully. Work out whether your use of instant reviewing has helped you to achieve the goal we set at the start of this section—did you see where you were going wrong as it happened and then make it better?

Review checklist

☐ Basic
Is there anything apparently sticking out of the subject's head?
Is the general composition satisfactory?
Is the lighting balance about right?
What about the angle of the head?
What does their body language say?

☐ Advanced
How is their expression?
Is there anything I can leave out of the frame?
Is there anything missing from the picture?
Do I have the picture yet?

It's that last question that becomes the most important one as you continue to shoot.

▷ **Moment of reflection**
In a series of portraits in black-and-white of Japanese designers, each had to be different for editorial variety. For this subject, standing in front of a restaurant he had designed, I wanted a reflective mood. The shoot lasted for about 10 minutes while the writer continued a conversation with him. These shots were taken during pauses in the conversation as he thought about the questions he was being asked.

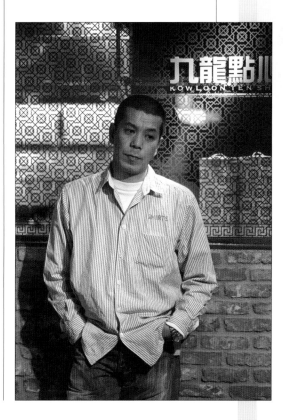

Activity and props

Keep your subject busy doing something useful and relevant, and they will soon forget the camera's presence, enabling you to sit back, observe, and shoot them at will.

Even if you are not particularly concerned with showing your subject firmly in context, as on the previous pages, there is often value in encouraging subjects to occupy themselves in some simple way. This is particularly useful if you don't yet have a clear idea of how to arrange the shot and the person feels awkward or self-conscious. On arrival, look around before shooting, to see if any obvious activity presents itself to you, and in conversation look for topics that will give you some clue about the person's interests.

This technique usually resolves itself into your subject holding something or demonstrating how something is done, and neither of these needs to be complicated. Try not to make a meal of any of this. Have camera, lens, and lights (if any) all set and ready to go. Shoot quickly and, as in all the examples here, you should have the shot in a few frames.

One of the standard variants is the interview shot, a staple of magazine and newspaper feature pages; it may often be necessary in professional

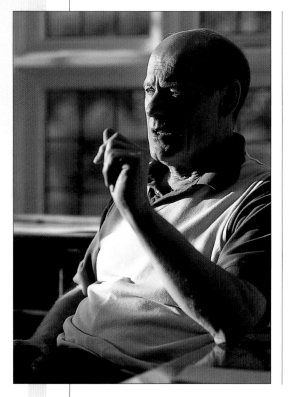

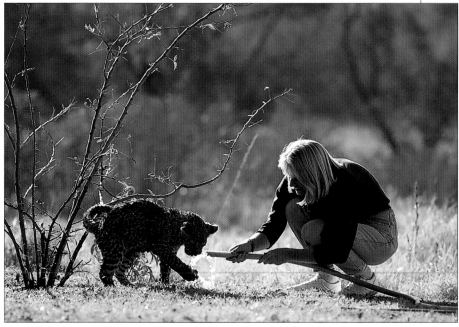

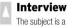 **Interview**
The subject is a calligrapher and graphic designer, and the interview was set up to take advantage of the lighting. The shot was chosen for the interesting position of the hand.

Cub
This woman took care of orphaned animals in South Africa. Young animals are among the easiest and most attractive props to work with, demanding close attention from the subject.

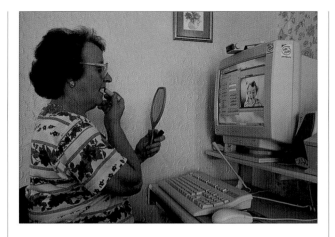

photography if the subject has time enough only for one session with the writer and photographer. The advantage for shooting is that it circumvents any problems of expression or self-consciousness, but the pose and camera position are still extremely important. The person who is being interviewed will usually be sitting; you should look for a position to one side of the interviewer, sufficiently off-axis so that it doesn't appear that the eyeline is just missing the camera. Shoot from the same height as the subject, and make sure that there are no out-of-focus foreground distractions, such as armrests or knees.

Waving hands, open mouths

The interview shot, aka "talking head," is (as has been described in the text) a fallback activity option, but there are pitfalls to this type of shot. Ideally, you need an animated expression—it should look as if the person is in the middle of making an interesting point. An open mouth in an expressionless face, however, is likely to look vacant. Some open-mouth positions look more convincing than others, so be prepared to shoot a large number of images from which you can the select the most successful one. Expressive hand gestures usually help the shot (try asking the person to explain something), but make sure that the shutter speed is fast enough to freeze the movement, and watch out for hands obscuring the face.

Internet
A grandmother in the north of England prepares for a video link on her new computer. The moment of applying lipstick was by far the most interesting action of the session.

City farm
At an inner-city farm which was established to introduce urban children to rural activities, this girl was hugging a lamb protectively as a pet—a natural and instant pose.

Lens focal length

Match the zoom setting not only to the type of framing you have in mind, but also to facial proportions. The most flattering perspective is usually from a telephoto lens.

All lenses will have the effect of distorting the human face and figure if you use them incorrectly. Some forms of distortion can be very flattering, and others can be used to give strength and emphasis to your work. Learning to use the right lens in order to create the right look is one of the key lessons to be learned in portraiture.

There are two ways that you can choose which lens to use for a specific task, and in portraiture one of them is far more desirable than the other. Sometimes the situation dictates that you have to shoot from a given distance and you can say, "There's my subject and here I am, let's see which focal length on my zoom works best." More often than not, you can say "My experience tells me that this particular focal length will give me the effect that I'm looking for," so you select the right lens for the job and move yourself to get the right composition.

Either option is valid, but the second is usually a better way to approach shooting people whenever possible. Being too close to your subject will usually make them uncomfortable, so the minimum amount of space that you need to give them is often a matter for personal judgement. Getting

A simple exercise

All you need is a zoom or a range of lenses (the more you use the better, but at least one wide angle, one normal, and one medium telephoto), a willing volunteer who is prepared to sit very still, a notepad and pencil, some paper, tape, and 10 minutes of your time.

Start with a standard focal length—around 50mm efl. Sit your model on a stool and stand back far enough so that their face fills the frame. Focus, check the framing once more, and, finally, shoot a picture. Now get your model to look 45° left and take another picture. Put a small piece of tape on the ground so you can find this position again.

Repeat this process with each lens (or focal length if a zoom). If your model is still awake, try shooting with each of the other focal lengths from the other pieces of tape on the ground.

By comparing the pictures side by side, you can see for yourself the effect that each of your lenses has on a person's face. You will find some of the pictures more pleasing than others, and some will be amusing. Not every subject's face will react in the same way when confronted with the same lens from the same distance, but you now have an idea of what works with your equipment.

closer than 6½ feet (about 2 meters) to start with is rarely a good idea, and this is one of two reasons why 85mm efl or 100mm efl lenses are generally considered to be "good portrait lenses." The other important reason is that by flattening the perspective, all the facial features are shown close to their true size. A wider angle lens used from closer to fill the frame will exaggerate the apparent size of the nose and front part of the face.

In general, telephoto lenses tend to be more flattering while wide-angle lenses can be used to add dynamic elements to the composition. These effects can often be magnified if you are shooting down toward your subject or if they are looking out of camera. Try the simple exercise opposite to see the effects for yourself—and to see how it works with your own equipment.

As much as possible, give yourself the option to shoot with different lenses, once you have achieved the look that you wanted before you started the session. Sometimes you will surprise yourself by shooting a better picture with the "wrong" lens, but most of the time you will simply add to your knowledge for next time.

Breathing room
Giving the subject space in which to feel comfortable will produce more expressive results. Moving backward, shooting from a slightly higher angle, and letting the lens do the work is, at times, the best option to take.

Expand perspective
As a technician is extracting a pearl from an oyster, the aim of the shot was to show the basic action while drawing attention to the pearl. A wide-angle lens, 20mm efl, exaggerated its size relative to the man.

Compress perspective
Two contrasting lens solutions on the same assignment. Here, an employee of a Japanese distributor examines a large pearl for blemishes. A telephoto lens, 180mm efl and stopped down for maximum depth of field, compresses perspective to bring together pearl, magnifying glass, and eye into close relationship.

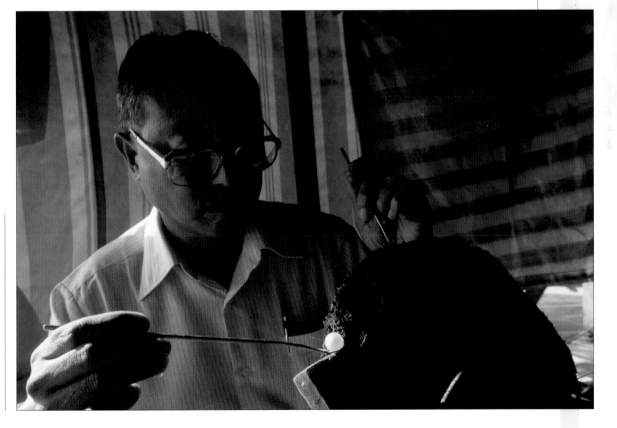

Torso

The "default" framing for a portrait, a head-and-shoulders view, is a standard solution that focusses on the key elements.

Over the years this has become the "classic" portrait composition. The blend of facial expression and body position that is made possible when you shoot the whole torso, head, and shoulders has become part of the culture, from magazines to television. Because this style of portraiture has become so heavily used across the world, much has been written about the various subtleties of pose and expression. Every detail has its own conventions and nuances, and here are a few elements to consider.

New ideas

Once you have started to master this familiar style, try a few variations on the theme:

☐ Try bringing your model's hands into the composition—leaning on the elbows with hands to chin, or perhaps running a hand through the hair.

☐ Typically, your portrait would fill an upright frame, so experiment with using a horizontal or square frame, and with looser compositions that bring an interesting background into greater prominence.

☐ Introduce one or two relevant props, such as a book or an item of sports equipment. You can use anything you like as long as it adds to the message you want to give about your subject.

☐ Use different lenses to alter the feel of the picture. Longer telephoto lenses will compress the perspective, which you might find more appealing (*see pages 86–87*).

☐ Shoot from a higher or lower angle to give a surprisingly different mood.

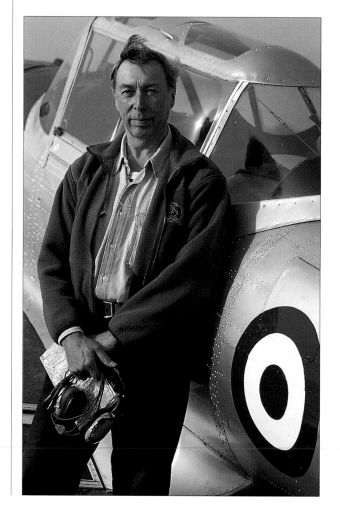

Framing to suit props

For this portrait of a pilot, I wanted the minimum background that would communicate his aircraft. The cockpit and roundel made a neat composition, but this meant cutting the figure at the knees—normally an uncomfortable framing. The problem was solved by having him hold his headset and chart in a natural-looking position.

☐ The angle of the subject's shoulders in relation to the camera is extremely important. If the shoulders are too square to the camera, then the photograph may look static and formal, and too much like an identity photo. Conversely if the shoulders are at a strong angle to the camera, the atmosphere of the portrait becomes unsettling.

☐ The tilt of the subject's head can make a huge difference. Upright and straight into the camera presents a look of honesty and solidity. If the head is slightly tilted to one side, it can look coy. Tilted the other way, it can look slightly quizzical.

☐ The height of the camera in relation to the subject. Safe and sensible is a few degrees above the subject's eyeline.

☐ The position of the subject's eyes also affects the image to a considerable degree. Notice the difference between the eyes looking straight ahead and looking out of the corner.

☐ In this moderately tight composition, your subject's clothing and hair will be highly visible, and play a part. Clothing is easy to change quickly.

☐ The background needs to be something relatively unobtrusive unless it has a constructive role to play in the photograph.

☐ The direction of the light is critical, and this requires thought. A good starting point is to arrange the picture so that the main light is facing your subject's chest. For more on this, see pages 40-41.

This list stresses the conventional, and is a good starting point even if you want to break out and try things differently. Rules in photography fall into two groups, and the classic portrait is a curious mixture of both types—technical ones that you break at your peril and creative ones that you will want to bend more and more as your work improves.

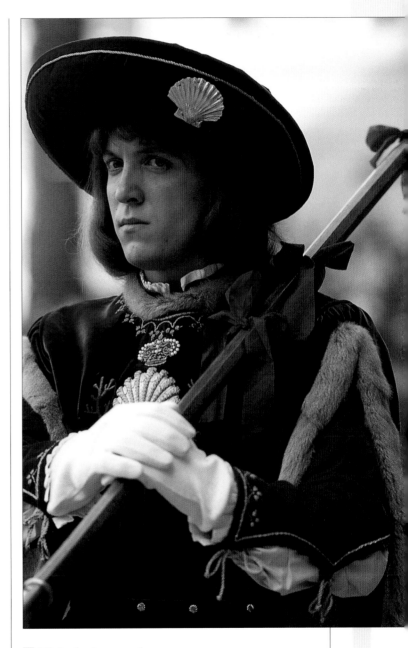

Historical pageant

A participant in the annual Palio in the Tuscan city of Siena. The position of his hands, elbow, and the hat determined both the framing and the camera position—an example of how the fine-tuning of a composition often depends on the details of the subject.

Full-length

Although it shows less of the subject's expression, pulling back to show the entire figure makes more of the pose and stance.

▷ Sidelighting
Full-length lighting from the side, such as from a large window on one side of the room, makes a dramatic difference to images of standing figures. As long as the figure is facing into the light, as here at this reception in Manila, the absence of shadow-fill is rarely a problem.

The full-length portrait enables you to show your subject in an entirely different way from the more classical, tighter compositions. By pulling back, you lose the detail of expression but you gain greater freedom to explore stance, posing, and body language.

One of the biggest difficulties that aspiring photographers encounter when trying to shoot full-length is attempting to fill the frame. The term full-length doesn't always mean standing up. It can equally be applied to lying down, sitting, or kneeling, so if you feel the need to fill the frame, start gently with a seated composition. In the section on expression we talked about facial features, angle of head, and eye contact as important factors, and these principles can be carried over to full-length portraits.

The arrangement of your model's limbs, the angle of their shoulders, and their position in the frame all assume the same level of importance that facial expression has in closer compositions. In almost the same way that we all learn to read facial expressions as children, we all have a basic knowledge of body language, and as photographers we can use that shared vocabulary to our advantage.

Legs can be straight or crossed, hands can go into pockets or behind the back, and arms can be stretched out or folded. Whatever you decide to do

Full-figure poses

Be prepared to suggest a pose if the person feels awkward. One typical problem for some people is what to do with their hands. These are some suggestions.

with your subject's limbs, body language experts will tell you that everything has a meaning.

When your subject is standing up, experiment with the transfer of their weight from one leg to the other and then equally between both legs. You can also try asking your model to lean against something—walls, door frames, and posts all make good supports and your model can lean with their shoulder, back, or hands. The list of possible poses and variations on those poses is almost endless. It is worth going through magazines and books to get an idea of what works. Some poses suit men more than women, the young more than the old, so it's a good idea to make notes and even keep a scrapbook so that you have some ready references when you are planning a portrait.

The other big challenge presented by full-length portraits is the relationship between your subject and the background. When the composition is tight, it is relatively easy to make the background incidental, but when you have the whole person featured it becomes more difficult. Foregrounds can also come into play, so be aware of the impact that anything between you and your subject might have on the feel of the picture.

In all types of portraiture it takes time to establish your own style. With fewer conventions about this kind of portrait, you are likely to feel a lot less certain when you start to experiment, but most photographers quickly learn to enjoy the freedom presented by full-length portraits.

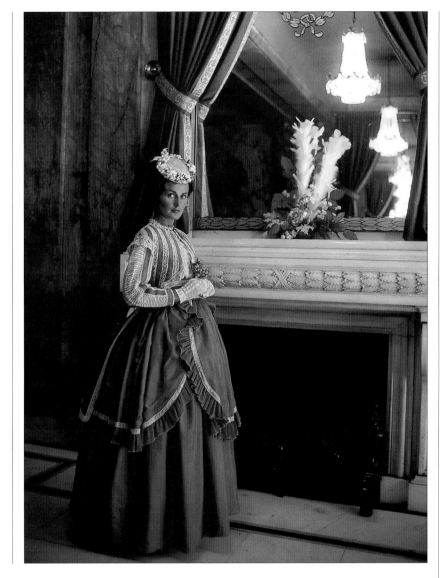

Period piece

One common reason for full-length framing is to show the clothing, whether for a fashion shot or, as here, to show a period costume. To complement the dress, the location chosen was London's Café Royal with its *fin de siècle* decor.

Face

Cropping in on just the face can produce the most intimate of all kinds of portrait, but demands the most care in technical matters of lens, lighting, and depth of field.

Some photographers regard this kind of portrait as a technical challenge, but the majority see it as the most intimate and revealing study in the whole sphere of portraiture. Framing a portrait so tightly that you show your subject's face on its own would seem to be easy. There is virtually no background to worry about, no body language to interpret, and your model's clothes won't dominate the photograph. The flip side of all of this is that there is very little room for error with composition, focussing, lighting, or expression. Indeed, facial expression usually dominates this kind of image.

There are many ways in which you can compose a portrait that concentrates on the face. The most obvious one is to include the entire head in a vertical frame, but this is often the least interesting solution. Using a horizontal frame and cropping the top of your subject's head can make a far more interesting portrait and it also increases the viewer's concentration on the eyes. The position of the eyes in the frame, the direction in which the eyes are looking, and the light around the eyes are all vital to the success of the photograph.

No matter which lens you choose for shooting such a tight image, you will be working with a relatively short depth of field. Using a 135mm efl lens your depth of field will be less than 2.5cm (1 inch) with an aperture of ƒ4 when shooting this close. Even if you can work with an aperture of ƒ11, you still only have less than 8cm (3 inches), which can easily mean that you have eyes in sharp focus and ears out of focus.

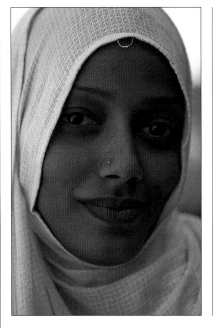

Eye contact
Direct eye contact with the camera dominates this shot, holding the viewer's attention. By shooting in shade on a sunny day (and making the appropriate white balance adjustment), I made sure that the eyes picked up strong highlights from the sunlit area behind the camera.

Check sharpness

The key parts of a portrait need to be sharp, and this means at the very least the eyes. If there is a danger of shallow depth of field, focus on these. Also ensure that there is no motion blur, either because your subject moves (blinking eyelids in particular) or because of camera shake if you are handholding. A full-frame view in the LCD display is too small to check for this, especially if you are shooting large, high-resolution images. Use the zoom-in controls to full magnification in oder to check that all is well on the first shot before continuing.

Digital cameras with smaller chips will give you greater depth of field, but it remains important to keep your point of focus on one or both of your subject's eyes. It's a matter of personal taste if, because of a shallow depth of field, you have to focus on one eye and the other remains unsharp. One school of thought is that it should always be

the nearest eye, while another says that if one eye is better lit than the other, you should focus on that eye.

The way that your portraits are lit makes a huge difference to their success. The closer you crop into the face, the more importance the subtlety of that light assumes—and that includes any catchlights in the eyes. Later sections of this book will expand on the ways that you can light a portrait, but whether you use ambient light or flash, this kind of picture will show off your abilities to master light.

◢ Reflected light

Also shot with a medium telephoto for a compressed perspective, this outdoor portrait makes use of a white wall and floor to bounce strong sunlight on to the subject.

▷ Studio shot

A studio-lit portrait in which different poses were tried. Chin on hand is a classic pose, and works strongly here because all else— background and clothing —is reduced to black.

Detail

Occasionally, a close-up detail of one part of the face or body can be both striking and revealing—an alternative and potentially eye-catching approach.

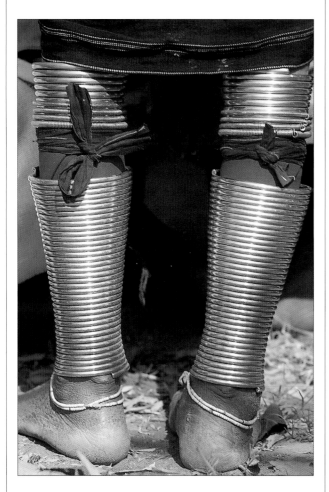

▲ Brass-bound legs
A woman of the Padaung tribe in eastern Burma, wearing the traditional ornament of brass rings encircling the legs. Unusual and decorative, they merited a photograph to themselves.

"In photography, the smallest thing can be a great subject," wrote one of the world's greatest photographers, Henri Cartier-Bresson. "The little human detail can become a leitmotif." He was writing about a principle, but one method of homing in on this is to shoot close detail. It's useful for two reasons. First, it increases the variety of images in your shooting by shifting things to a different scale, and second, it enables you to make a different point by focussing the viewer's attention on an element that might otherwise pass unnoticed.

In portraits of people, close-up means individual parts of the body, and once you start looking with this kind of detail in mind, you'll find that there is a rich variety. There is, of course, an element of intimacy in this, because such close-focussed images take the viewer closer than they would normally ever be to a stranger. This brings with it the slight risk of appearing uncomfortably close, but set against this is the opportunity to surprise the viewer, and on occasion even to add sensual overtones.

The lens of choice is a medium telephoto lens with close-focussing ability, or the equivalent setting on a zoom lens. A specifically designed macro lens is ideal, but most lenses nowadays are capable of focussing close enough in order to fill the frame with, say, an eye or a pair of lips.

Depth of field becomes an issue at such short distances, and while occasionally you can make a shot work with shallow depth—selective focus, in other words—soft areas in a close-up image usually look like faults. Basically, stop down to a small aperture and check the front-to-back sharpness by enlarging the view on the LCD screen.

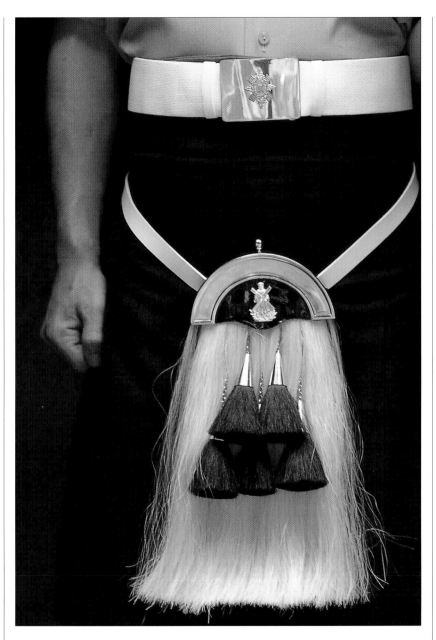

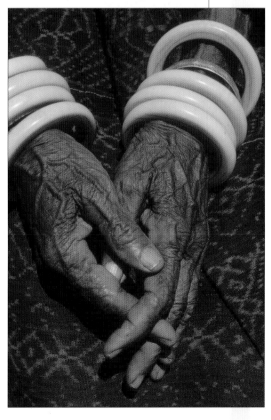

Black Watch
A geometrically exact composition deliberately matches the precise turnout of a guard of the Black Watch regiment. A low camera viewpoint was chosen so that the belt, forearm, and lower fringe of the sporran were all aligned with the edges of the frame.

Rose picker
Wearing red protective clothing, a young Bulgarian girl rests during the annual rose harvest, holding a single flower in one hand. This close, almost abstract shot stood out for its very simplicity.

Hands
These are the hands of an old woman in Indonesia. Set against her tie-dyed dress, with a stack of ivory bracelets for contrast, it was an irresistable shot.

Twos and threes

Photographing more than one person at a time introduces different dynamics of direction and rapport, and calls for a compositional plan.

By shooting people together, you instantly suggest that there is some form of relationship or bond between them. They could be mother and daughter, two boxers about to do battle in the ring, or a trio of war veterans who have been reunited for the first time in years. If you can imagine any kind of relationship, then at least one photographer somewhere in the world will have been asked to shoot it, probably in the last week. Any way that you arrange your subjects will have a message, from sisters holding hands to our two boxers standing back to back. As a photographer, you need to know what the social dynamic of your group is and be prepared to arrange them in a way that reflects their relationship and makes a good picture.

It is almost inevitable that you will find that your rapport with one is better than with the other, so you need to have a strategy for dealing with that. You can't keep eye contact with two or three people at a time, so you have to direct your remarks clearly if they are to an individual, or more generally if they are aimed at everyone. Remembering names is important.

With two or three people, you can either have them side by side or one in front of the other. If you decide to have one closer to the camera, then you have to have a legitimate reason for choosing to shoot that way because it is quite likely that you will be asked to explain why. Good reasons come in many forms, and a simple answer like "It makes the composition of the photograph stronger" are often enough if you give your reason in a confident and authoritative manner. Differences in height can be overcome by seating one or two people or by shooting from a higher angle. The most important thing is to have as much information as possible about the people before you shoot, so that you can make some plans about how you are going to group them. Here are a few things to think about.

More often than not, you will have your subjects looking into camera. It is worth experimenting with having them look at each other, or at the same point in the distance above and behind the camera, or even have one looking into camera and another looking at something else. Digital gives you the option of shooting more at no extra cost and learning from your experiments. This feature is never more useful than it is in small group portraits.

▲ Triangular composition
Three-figure shots usually contain a natural potential for a triangular structure. Here, in this shot taken in a crèche in Montreal, it has been deliberately strengthened by the viewpoint, which shows two triangular relationships—between the heads and the outline of the three figures.

Before you start

☐ What clothes are they going to wear? In general it is a good idea to have a theme, and that might be based on a style of clothing or on a color scheme.

☐ Where are you going to shoot? The location will often dictate how you arrange your group and whether you will have easy access to chairs or cushions.

☐ How is the photograph going to be lit? If it's going to be available light, will you have enough depth of field if you want to stand one person behind the other? If you are using flash, can you get the light evenly distributed across two or three people?

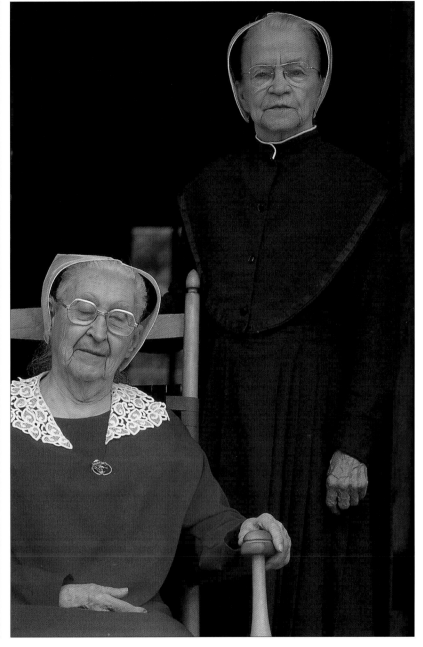

◄ Side-by-side

This strong compositional arrangement combines key similarities across the subjects—costume, general stance, and posture—with powerful vertical elements (the oars). What's interesting is how this highlights differences in individual attitude and expression.

▲ Sitting and standing

One solution to the question of how to arrange two people while keeping the design interesting is to vary the height. In this portrait of two elders of a Shaker community, circumstances dictated the composition, as one of the ladies had difficulty standing. A Shaker rocking chair made an ideal prop.

Groups

Put several or many people together and you have a very different situation in which you have to play the part of stage manager and deal with group interaction.

Most of us have been in a classic sports team or school class photo lineup with two rows, one seated and the other standing. This is another photographic convention that is worth paying attention to, if only to get ideas about how to break away from it. The best lesson you can take from the two lines style of picture is that having some chairs or benches placed in advance will give you a starting point.

Some hints and tips

- ☐ Tell the group that the whole session will go more smoothly and produce better results with their cooperation.
- ☐ Get the whole group to look in the same direction by giving them a point to look at. The maker's name of your camera is a good one.
- ☐ Make the session as lighthearted as you can without resorting to telling long and rambling stories.
- ☐ Informal groups often look good when shot from about 30° above their eyeline, so consider bringing a stepladder.
- ☐ Everybody blinks. The larger the group, the more certain it is that somebody will have their eyes closed as the shutter opens. Tell your group this and use it as a reason to take a large number of pictures.
- ☐ The "noise" associated with digital cameras at high ISO settings will show up really badly in large group photographs, so try to shoot at your camera's best quality settings.
- ☐ It is always tempting to shoot large groups with wide-angle lenses. Be aware that the distortion associated with even the best quality lenses will do strange things in the corner of the frame, so try to get a bit farther back than you would think necessary.
- ☐ Try to end with a few "fun" frames so that the session ends on a high note.

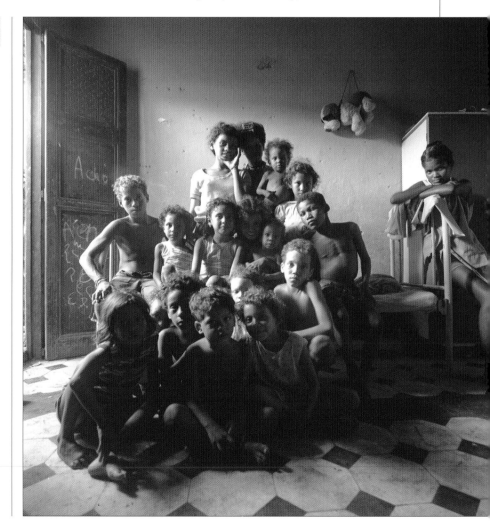

Picture the scene; you have arrived and got your camera ready to go. If you are using lights, they are unpacked and tested. So far, everything is going to plan. Eight burly men arrive and they all know each other, while you might have met only one or two of them before, and they want to have a laugh and a joke with each other. It's absolutely vital that you establish control of the situation, and you need to use some subtle psychology to help. Having some of the setup already in place will say to them that you probably know what you are doing, and the most obvious signal is to have your camera on a tripod pointing the right way and looking ready for action. Even if you don't need to use a tripod, it's a way of stating that you mean business. You need to establish if there is a leader or captain in the group, or any other hierarchy, and then quickly get them into the positions that you had planned. You are in control, this situation doesn't really offer room for discussion and democratic decision-making. Politely tell them what you want and where you want them. In other words, you need to combine the skills of an orchestral conductor with those of a traffic cop.

The more that you break away from the conventional lineup, the more certain you have to be in your own mind about what you want and the more clearly you have to be able to ask for it. Hesitation and uncertainty will mean that you start to lose control, and once you lose control it's very hard to reestablish it. Large groups need the photographer to work quickly and methodically.

Planning the quality and output of light is a vital step in preparing your group photo. The lighting should be as even as possible, so avoid direct sunshine and its accompanying shadows. If you are lighting the group yourself, make sure that you test the whole area where the people will be. There should be less than half an *f*-stop variation across the whole scene.

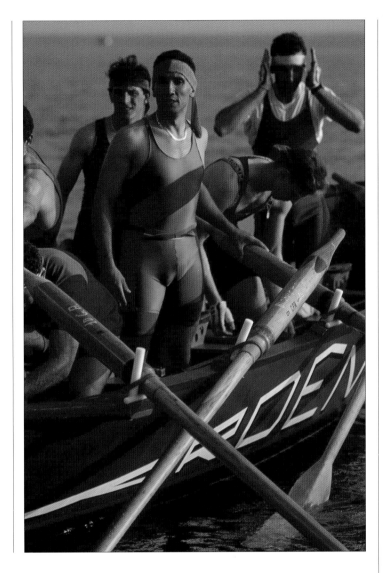

Maintaining the shape

What began as a small group portrait in Colombia, expanded as friends from the street joined in. The only way to keep cohesion was to step back and arrange the new group both as a compact, triangular shape and vertically—some standing, some sitting, others squatting.

Regatta crew

An impromptu group portrait as the CK winning crew of the Livorno regatta in Tuscany returned to their mooring. With no time to lose, the shot was simply composed, making the most of the strong colors by filling the frame. The diagonals of the oars held the composition together.

Natural light

Portraits outdoors have the advantage of spontaneity, but only certain conditions are flattering for portraiture; in others you will need to adapt and improvise.

Many nonphotographers assume that bright sunshine is the photographer's friend, and that dull days are the enemy. For landscapes and architecture that might be generally true, but when we are photographing people there is an optimum quality of light that can be very elusive. One of the greatest skills that a portrait photographer can acquire is the ability to look at the natural light and know how to work with it, adapt it, and get the best from it.

Direct, midday sunshine is extremely difficult to work with. The shadows are hard and from above, and the image contrast is high. There is almost no circumstance where you would choose to shoot a portrait in these conditions. On days like this, most photographers would be looking for "open shade"—not found in the hard shadow of a building but rather under trees or in areas of shade near areas of natural reflection. Here, shadows are tempered by light reflecting off surfaces such as sand or water.

These conditions are not necessarily easy to find, so photographers have developed techniques over the years to help simulate these conditions. Some go to the trouble of erecting their own tents made out of special light diffusion material, while others make use of large translucent umbrellas to create their open shade. These are commercial products, but it is pretty simple to develop your own system for producing the right quality of light. The real trick with getting the light to do what you want is to make sure that the principal light-source is hitting your model from a flattering angle. You can introduce your own reflectors to bounce light back at your subject. These are also available commercially and most of them fold away into smaller bags when not in use. Big 6 x 4 feet

▽ Bright sunlight
Not normally the lighting of choice for a portrait, direct sun worked well in this shot of a young Beijing boy wearing his father's military cap, due to the strong colors and simple compositional elements. Being almost frontal, the sunlight cast no awkward shadows.

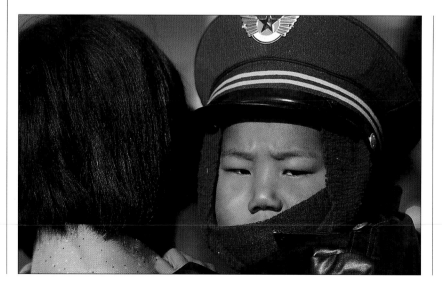

(180 x 120cm) white, gold, or silver reflectors can be a good investment if you intend to do a lot of natural light portraiture. Holding them in place represents a challenge if you work alone—especially if there is any wind—so consider all of these options as you are planning the shoot.

Occasionally you get the kind of misty, watery sunshine that watercolor painters adore and this produces a wonderful quality of light for portrait photography. You cannot plan to get this kind of light in advance, but wherever you are shooting there will be certain times of the year where the chances of getting good light are improved. Alternatively the light just after dawn and just before sunset can produce an excellent quality of light for shooting people.

Sometimes the light is just plain horrible. It's on these days that your skill as a natural light photographer is called into action and you need to use all sorts of tricks to make the light seem a lot better than it really is. Later sections of this book cover the use of your camera's own flash and location studio kits, so all that needs to be said at this point is that on really bad days you need to introduce your own light to supplement what's there already. Alternatively you can consider shooting your portraits with the intention of working on them in the computer, and this is also covered later in the book.

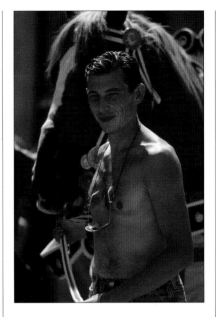

Check histogram and highlights

Invaluable though the LCD screen is for displaying the image just shot, don't rely on it totally for exposure accuracy. The surrounding light conditions will affect your judgement, as will the inevitable viewing-angle problems (look at the screen from several degrees off-axis and the image will appear lighter or darker than it really is). If your camera can display the histogram and highlights, use these options—they give you an objective analysis of the exposure. The histogram should show you, as here, that the skin tones are located somewhere in the middle; exactly where depends on the intrinsic darkness or lightness of the skin. For more on skin tones, see pages 68–69. "Highlights" in this context means pixels that are out of range and blown out.

Backlight
Bright afternoon sunlight bouncing back up from the stone-flagged street provided enough shadow fill to make this backlit portrait of an Italian trainer and his horse readable. Highlights around edges are typical of this atmospheric kind of lighting.

Reflection
An extremely bright, clear day with a high sun offered only harsh sunlight or deep shade. One solution was to position the girl in the shade of a tree with sunlight in front and behind, and to use large sheets of white paper to reflect light on the face.

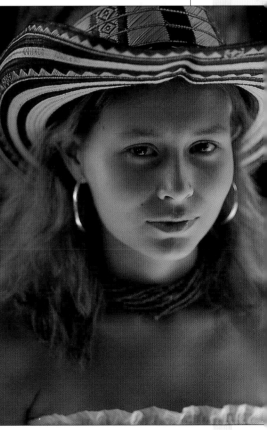

Available light

Existing interior lighting, however mixed and unpredictable, has the advantage of being normal and familiar, and digital cameras are exceptionally well equipped to deal with it.

Artists throughout the centuries and photographers since the time of Fox Talbot have used "North Light" in their studios, and this indirect daylight is often available to the modern portrait photographer. It is one of many potential light sources indoors, all of which have different qualities and different colors. The white balance capabilities of your digital camera can easily cope with any blueness that results from a north-facing window—and from any of the other potential light sources that are being used.

Although light levels are much lower than outdoors, and the color of the lighting can vary greatly (*see below*), you can still make good portraits indoors, without using flash. By using a tripod, some reflectors, moving the odd table lamp, and getting the camera's white balance right, you can arrange your subject in such a way that you still get a flattering image. Some rooms have multiple light sources, so it might be a good idea to check that they are all of the same type. If they aren't, you have to decide whether to turn some of them off or to rely on a good custom white balance to sort out the various shifts. You might also want to consider shooting with a black-and-white final image in mind.

The low levels of light that are associated with available light photography usually dictate that your subject needs to be still, and that normally means them being seated. Avoid sitting your model directly underneath the main light source, because the most flattering direction for a main light is from just above their eyeline. Look for table lamps and standard lamps that can be moved in order to give a kinder light, as well as for angle-poise desk lamps, which you can put into service if diffused a little. A small reflector will also be very useful.

Lighting to expect

☐ **Daylight through a window**. This can be extremely useful if it is indirect. Treat it like the natural light covered in the previous section and be prepared to use reflectors and screens to modify it. This light will often have a blue balance.

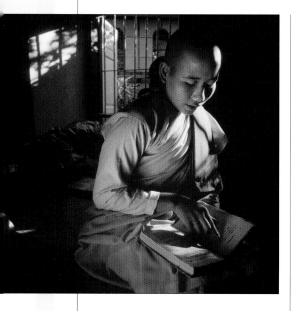

Study
A young Burmese girl in a convent near Mandalay concentrates on learning a Buddhist scripture. The appeal of the setting lay in the light at this late time of day. Strong sunlight entered through a window on the ring right and bounced off the floor to give a natural, but essential shadow fill.

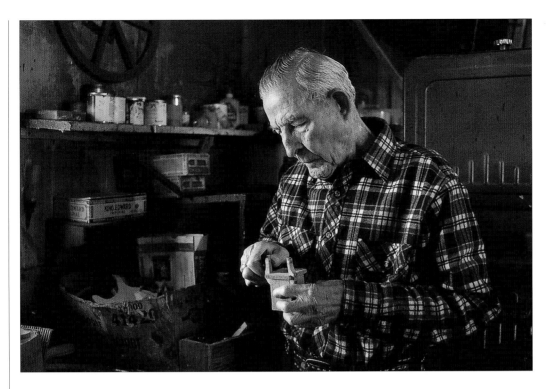

Single window

Side-lighting from a single window just out of frame to the left provided a clear outline to the face and hands of this West Virginian craftsman, separating his image from the background of the workshop. His position, carefully arranged, was important to make the best use of this—the light catches not only the forehead, nose, and chin, but also his left cheekbone and eye. Shadow fill came from a light bounced off the wall on the right.

□ **Tungsten light**. Normal filament light bulbs are often weak, so you might have to use a high ISO speed, slow shutter speeds, wide apertures, or even a combination of the three. It is often a good idea to use a tripod in this case. Tungsten light is very orange.

□ **Fluorescent light**. Mostly found in striplight tubes, this kind of light gets a bad press. It is normally fixed to the ceiling and so gives off a harsh light from exactly the wrong direction for good portraits. In just the same way as tungsten lights, you will need to think about using high ISO or slow shutter speeds and about employing a tripod. Fluorescent light has all sorts of colors, but is most commonly green.

□ **Mercury vapor lights**. These are increasingly common, even in small interiors. Visually white but usually blue to blue-green in a photograph.

□ **Sodium lights**. These are usually reserved for large areas such as sports halls and some concert halls. Sodium is very yellow in color and mostly gives unpleasant light.

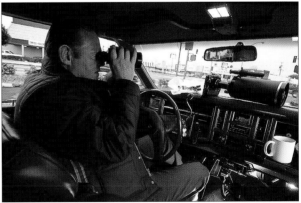

Automobile interior

This posed shot of a private investigator checking a market stall for counterfeit clothing from his automobile needed lighting help. Everything from the street exterior to the surveillance equipment inside needed to be legible. A single flash provided the necessary lightening of the interior shadows.

On-camera flash

Use the camera's built-in flash to supplement the existing lighting subtly rather than to overpower it. Full-on flash is rarely flattering, but understanding its limitations will help you to get the best out of it.

The quality of the flash units now supplied for digital cameras is such that you will probably end up with a correctly exposed image, but the nature of the light makes it unlikely that you will end up with a worthwhile portrait.

On-camera flash falls into one of two categories: units that have only the ability to point directly forward and those that can be used to bounce the light off a reflective surface away from the camera. The second category will usually be a hot-shoe type flash unit with a bounce and/or swivel head, whereas the first will usually be built into the camera. Some of the built-in strobes have a maximum effective range of only about 6½–10 feet (2–3 meters.)

The best use for on-camera flash, when shooting people, is to provide a supplementary or "fill-in" light rather than using it as the main light source. This is useful in various conditions, including the following. It can help remove deep shadows when shooting in strong, directional sunlight; most cameras nowadays have a facility automatically to reduce the flash to achieve this effect. A variation on this is that you can correctly illuminate the foreground when you are shooting against the light, avoiding your subject becoming essentially a silhouette. Another technique is to use flash to freeze your subject when the rest of the image is rendered blurred by a slow shutter speed. And flash can simply add some light and life to your subject in a situation where the picture would otherwise have been flat and dull.

Under most conditions the effect that you are looking for when you use supplementary flash is a subtle one, adding just enough light to lift the image rather than completely dominate it. All of this is a question of balance, between the ambient lighting and that from the flash, so be prepared to vary the mix between the two. Once again, digital's facility to check as you shoot takes the uncertainty out of this.

Fill lighting
Typical of traditional Indian shops, this family business, the oldest perfume business in Delhi, opens directly on to the street, posing an obvious contrast problem. The action at the shop entrance was key, and the exposure was set for this, but at the same time it was important to hold some shadow detail on the boxes inside. A small flash output, set manually and calculated by trial and error, provided shadow fill. The camera's LCD screen review is invaluable for this kind of lighting uncertainty.

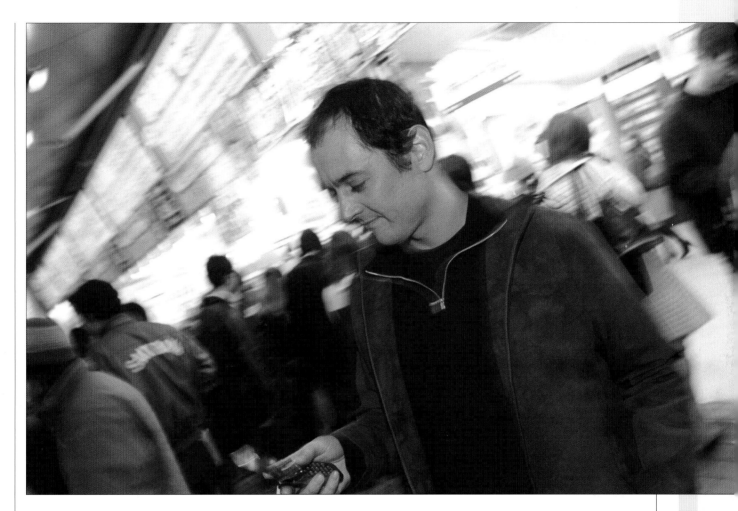

Fill flash

Contrast control is what fill flash accomplishes best. The classic case is where you have a bright background and a dimly lit subject in the foreground. You add enough flash to bring the foreground subject up to the same exposure as the background, "filling in" the shadows. Otherwise to expose the foreground correctly would have left a badly overexposed background. Subtle use of flash is the key.

If you watch professionals such as wedding photographers, you will quickly realize that they use flash most of the time. They often set the flash at between one and two f-stops under the correct exposure, so that areas of shadow get proportionally more flash than areas of highlight, but not enough to burn the highlights out. Most modern cameras have an automated version of this function, but learning to do it yourself means that you will have far more control when you use fill flash for this purpose.

Rear-curtain flash

To capture something of the bright nighttime energy of Tokyo's downtown Shibuya district, I used a combination of slow shutter speed and rear-curtain flash for this portrait of a sculptor. Panning the camera in a jerky movement captures the contrast between blur and sharpness.

On-camera flash

In some situations, direct on-camera flash will be your only recourse. Such lighting works best when there are strong shapes and bright colors to work with.

Basic portrait lighting

When you are using photographic lighting, there is among the many permutations a basic set that is guaranteed to deliver satisfactory results—a useful starting point.

Professional photographers often need to set up portrait sessions well in advance, particularly so if the photograph is to be taken indoors with lighting. This makes things rather less fun and simple than an on-the-spot casual shot, but it does make it possible to be inventive and to guarantee a particular type of image. Lighting is a key element in portraiture, and if you are building it from scratch, rather than relying on existing light, you'll find that softer rather than harder lighting suits most faces.

The basic configuration of the human face dictates some standard principles of lighting. One of the most basic and reliable lighting setups features one main light, diffused (such as with an umbrella) and a little above the face to one side and in front; a weaker second light or silvered reflector fills in shadows; a spotlight from a distance behind can highlight hair or the side of the face. The main light is responsible for the basic modeling, the fill-in light reduces contrast and lightens shadows, and the "effects" light, normally well behind the subject but positioned or shaded so that it does not cause lens flare, is used to pick out highlights in the hair or to brighten the outline of the head and shoulders. To help lighten the under-chin shadow, which is often the deepest, the sitter can be asked to hold a simple reflector in the form of a card on which is pasted crumpled aluminum foil.

There are, of course, as many ways of lighting a face as there are portrait photographers, and it is worth experimenting with different styles. All the suggested positions of the lights or reflectors can be changed as necessary.

A simple set

A typical lighting setup for head-and-shoulders portraiture uses an umbrella as the main light, with fill-in from a second light bounced off a large white board known as a "flat." Polystyrene/styrofoam board is often used for this. An effects light, high and behind the subject, is fitted with a "snoot" to concentrate the beam on a small area. Finally, a background light is here placed on the floor, pointed diagonally upward onto a wide seamless roll of background paper for a graded effect.

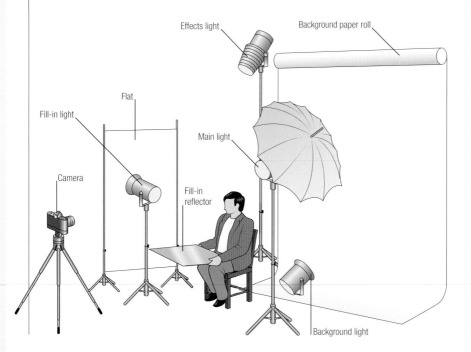

Effects light

Background paper roll

Flat

Fill-in light

Main light

Camera

Fill-in reflector

Background light

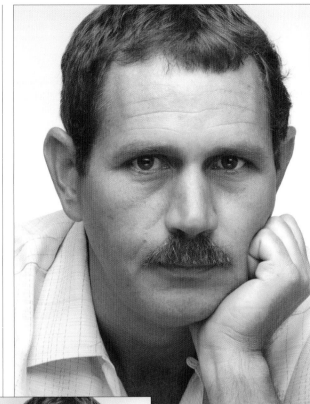

Hair
The hair looks best when at least partly backlit, giving it life and sparkle.

Ears
If the model has unusually large ears, only altering the pose will help. A three-quarter view will be better than straight on.

Cheekbones
These are an important feature in photographic portraits. Strong, high cheekbones are particularly photogenic.

Nose
There are no particular problems with lighting the nose, although it may be necessary to prevent it looking too prominent. Hard crosslighting will cast a shadow and accentuate the nose unpleasantly. Lighting which makes it less obvious will be more effective.

Forehead
Unless shadowed by the hair, the slope of the forehead can reflect strong lighting and appear overexposed. Diffused lighting reduces this problem.

Mouth
The mouth does not generally cause lighting problems. But be careful with red lipstick, which will look very dark on black-and-white film and may also be more prominent than intended in color.

Eyes
The sockets often need extensive fill-in in order to prevent them looking like deep pits.

Chin
Because the chin can cast a hard shadow with the overhead lighting which is best for other features, a crumpled foil reflector placed beneath it is generally an effective source of fill-in.

▲ Full-face framing
As in the portrait on page 31, full-face framing offers only a few varieties of pose. Most typically, these involve the use of one or both hands. The lighting used here was overhead/frontal, with shadow fill for the lower planes of the face and the eye sockets from a crumpled aluminum foil reflector underneath and just out of frame.

How the face reacts to light

The shape of the human face determines to a great extent the way lighting is used in portraiture. The approach will depend on the result intended—a soft beauty shot or a vigorous portrait, for example—but some principles must always be observed. Lighting can additionally be used to strengthen the best features of a face, and play down those that are unattractive. Such decisions must be taken in relation to the circumstances—the lighting being built up and modified as you go along.

Pro lighting

Enlarge your repertoire with high-powered, freestanding flash units, designed to be used with a variety of attachments for modifying the light, some of them made specifically for portrait photography.

Professional photographic lighting was originally developed for use in studios, and as such is mains-powered, although nowadays there are also compact battery-powered kits for location use anywhere. Standard professional studio lights have three valuable properties: their light output is much higher than that from a camera flash unit, they can be used in multiples, and they accept a wide variety of fittings to diffuse, concentrate, or otherwise alter the quality of the light. Digital cameras' adjustable sensitivity, and their greater depth of field than that of medium- and large-format cameras, makes the light output a little less important than it used to be, but being able to synchronize several heads together, separately modified, is still the key to creating sophisticated lighting effects.

Flash is standard, whether it is configured as a power pack with several heads attached by cable, or as individual monoblocs, in which each head has its own capacitor and controls. The heads each have a tungsten modeling lamp next to the flash tube so that you can see in advance what the lighting effect will look like, and the flash output is adjustable. Asymmetric distribution on a power pack enables heads to be adjusted individually. Flash synchronization can be by means of sync leads or photo-sensor, but most consumer-level digital cameras lack this kind of sync socket.

3200K tungsten lamps are less popular because of the heat they generate, which can be uncomfortable for the sitter and limits the diffusing attachments that can be placed in front of the heads, but they have a distinct advantage when you need supplementary lighting in interiors on location. Fitting a blue gel in front of the light brings the color balance to that of sunlight, so that they can be used to add to existing daylight.

Monoblocs

Monobloc flash units contain the power supply and controls within the body of the flash itself. Two, three, or more units can be combined into various lighting setups. A flexible, easily portable lighting solution.

Esprit Digital 750 Pro

Esprit Digital 750 controls

Flash lighting

Flash lighting is the workhorse of most portrait studio setups. Opinions differ over whether monobloc units (*see opposite page*) are a better choice than a power pack and seperate heads, although both have advantages in different situations.

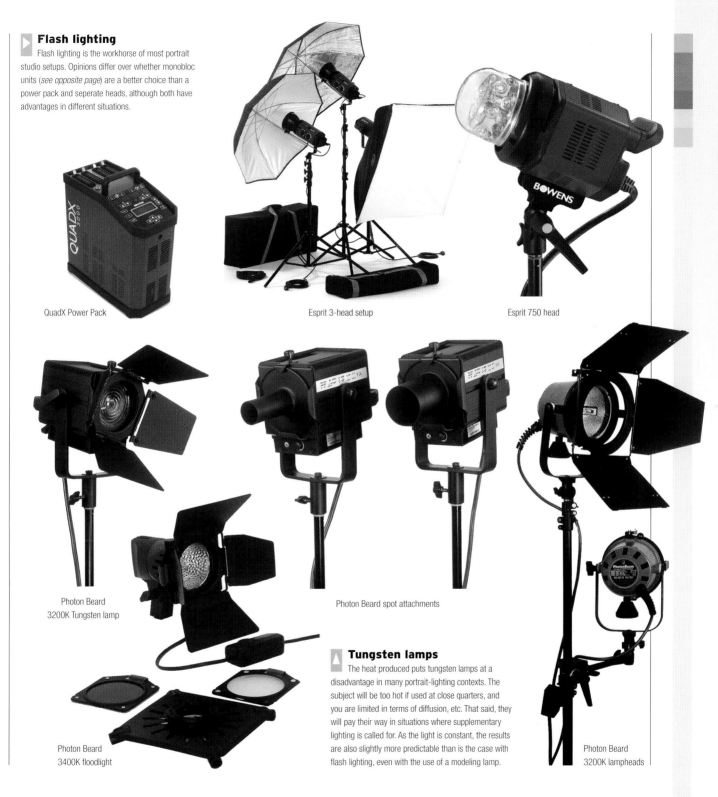

QuadX Power Pack

Esprit 3-head setup

Esprit 750 head

Photon Beard
3200K Tungsten lamp

Photon Beard spot attachments

Photon Beard
3400K floodlight

Photon Beard
3200K lampheads

Tungsten lamps

The heat produced puts tungsten lamps at a disadvantage in many portrait-lighting contexts. The subject will be too hot if used at close quarters, and you are limited in terms of diffusion, etc. That said, they will pay their way in situations where supplementary lighting is called for. As the light is constant, the results are also slightly more predictable than is the case with flash lighting, even with the use of a modeling lamp.

Softening the light

Faces usually look at their most attractive under soft lighting, and the techniques for spreading the light from a lamp are essential to master.

Portraits call upon softened light more than any other type of photograph, for the single reason that the human face, with its structure of planes, recessions, and protrusions, looks more attractive by convention when the transitions between highlight and shadow are smooth and gentle. You might occasionally want to emphasize lines and wrinkles, or create a high-contrast drama, but the general run of portrait photography, for the reasons already discussed (*see page 9*), overwhelmingly aims for the attractive.

Technically, soft light is achieved by increasing the area of the light source relative to the subject. A point of light casts hard shadows on a large subject; a light the size of a window gives almost no shadow to something the size of an apple held close to it. The standard method of softening a light is to shine it through a much larger sheet of translucent material, as in a so-called soft-box, and then position this close to the subject.

An alternative is reflection, bouncing the light off a surface, and this is the principle behind the ubiquitous portrait attachment, the umbrella. There are endless variants of these two systems: you can hang sheets of plastic or tracing paper between the light and the person, or use differently shaped soft-boxes, or line the umbrella with silver or gold material, or bounce the lights off freestanding white-painted boards known as flats. Studio photographers often tinker with lighting combinations in order to arrive at a special style.

Soft-boxes
Soft-boxes, which attach directly to the light source, provide an effective and popular method of diffusion. The amount of softening can be decreased or increased by moving the screen nearer to or farther from the source.

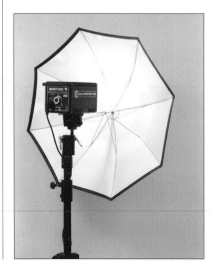

Umbrella
The standard equipment of nearly any portrait photographer, the umbrella can be used to reflect light from the source onto the subject for a softer effect, or turned around and used as a diffuser.

Spotlighting

Concentrating the light is in many ways the opposite of diffusion and reflection, focussing on one small area with great intensity and high contrast. While they are rarely employed as a main light, spots are valuable when used from behind the subject slightly off-axis, illuminating the outline and edges of the hair. Spots can either be lensed or in the form of snoots (a long black-painted barrel, often tapered).

Using umbrellas

Part of the reason for the ubiquity of the umbrella in portrait studios is its versatility. By changing the position and angle of the umbrella, the distance between it and the source and the reflective material, it is possible to create a wide range of lighting types, from highly softened to a more concentrated reflection.

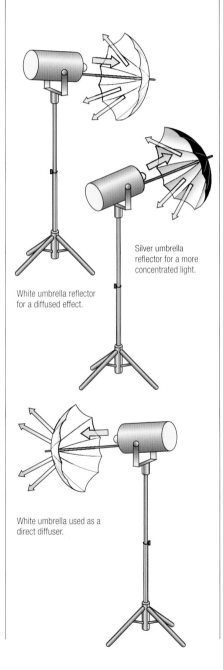

White umbrella reflector for a diffused effect.

Silver umbrella reflector for a more concentrated light.

White umbrella used as a direct diffuser.

Diffused lighting

The diffusion from a rectangular area light provided just the right balance between being directional and casting gentle shadows on the model's neck, shoulder, and hand, and at the same time bathed the pearls in soft highlights.

Portrait studio

Bear in mind that a studio is simply a space in which you can control the lighting, and does not have to be a costly, state-of-the-art environment. Save money by building and painting your own fittings and backdrops.

While a professionally equipped studio can be a daunting investment, it is by no means the only type. Naturally, professional photographers who shoot portraits of this highly controlled type, and do it constantly for a living, can justify the expense and upkeep. It may also be necessary for them to demonstrate their status in the industry. Clients have varied needs, and a quick change of idea or layout for a fashion shoot, for example, may require extra lighting, a different background, or more space. It helps to be able to accommodate new requests within the existing studio facilities, and this makes for an inevitable redundancy, which costs more.

But if you don't need to impress, and if you are prepared to go through a little more specific planning and preparation, all kinds of interiors can be turned into studios. The fundamental requirement is space—between the camera and subject, between subject and background, and between lights and subject. What dimensions you actually need, rather than would simply like, depend on your preferred style of shooting and lighting, as follows.

Calculating space and distance

Add together the figures from both charts to arrive at the minimum length for a studio space.

A	Head-and-shoulders	Torso	Full length	Group
50mm efl	1 m	1.5 m	3 m	4 m
100mm efl	2 m	3 m	6 m	8 m
150mm efl	3 m	4.5 m	9 m	12 m
200mm efl	4 m	6 m	12 m	16 m

B

Shadow-free background: about 1.5 meters behind
Background separately lit: about 2 meters behind
Backlighting for subject: about 2.5 meters behind
Backdrop illuminated from behind: about 3 meters behind

Three things determine the length of the studio space: the lens focal length, the framing of the subject, and the separation between the subject and the background. A longer focal length, as we saw on pages 24-25, gives more attractive facial proportions, but needs more distance. The farther you are from the sitter, the less easy it is to maintain a rapport, and a natural compromise is a focal length between two and three times standard. In other words, an efl of 100mm or 150mm. Head-and-shoulders framing is the most common, and this would typically need a throw of about seven to nine feet from camera to subject. As you'll need a background, more often than not in the form of a seamless paper roll or the painted wall, it's an advantage to have some distance behind the subject so that it can be lit separately and so that the person's shadow from the main light does not fall on the background. Ideally, allow at least six feet.

The portrait studio
Tight organization is needed to create an effective space and leave enough room for different setups. Office space (bottom left) might not be a necessity, but an area for dressing and makeup (center left) should be considered a basic requirement.

Studio on location

A portable lighting kit enables you to shoot people wherever you want to, avoiding the need to turn part of your home into a studio.

If your kit is lightweight and well planned, if it's reliable and quick to assemble, then you can light as much of your work as you want to. The concepts of the pro-lights discussed in previous sections can be carried forward into extremely versatile outfits for use anywhere. You could use mains-powered strobes with extension leads for some jobs, run them from a generator or car voltage inverter for others, or avoid the need for an AC power supply altogether by opting for battery-powered lights.

Everything that is available for the studio is also available in a simpler, lighter-weight version for the portable kit, although most photographers tend to keep the traveling outfit down to a manageable size. A good rule of thumb is to make sure that you can carry all of your lighting kit and your camera gear so that you are never in the situation of having to leave some of it unattended. One of the less expensive options for a location kit is to use one of the higher-output hot-shoe style strobes with additional batteries.

One of the main advantages of using battery-powered strobes on location is that you don't have as many cables lying around. All cables should be taped down or held down with rubberized safety strips. Photographers accustomed to working on location generally use some form of remote triggering system, such as photoelectric slave cells, radio control, or infrared. This reduces the number of cables and enables you to shoot with flash units in more interesting positions. There is a wide variety of remote triggering devices on the market, so it's worth investigating what will work with your outfit.

Basic requirements

- ☐ The light source itself. Most photographers would advise that you have more than one, and with an output that is both high and variable.
- ☐ A means of supporting the light source and holding it in place, which normally means lighting stands and adaptors for holding the flash units.
- ☐ Light modifiers. The most common are umbrellas and soft-boxes, but you can also use a wide variety of reflectors and sheets of diffusion materials held in place with clamps and tape.
- ☐ Power supply. If your strobes are AC, then you need a wide range of extension cables and possibly a voltage inverter for use from a car. DC strobes need batteries, and plenty of them.
- ☐ A wide variety of accessories, from gaffer tape to colored gels, as well as a means of triggering your flash units.
- ☐ Versatile and rugged cases and bags for carrying everything in.

A traveling kit

A typical location kit would include a single power pack with two heads, plus extension leads, umbrellas, and stands. Other accessories, such as a radio-controlled trigger kit, should also be considered, and the whole thing needs to fit into neat cases for easy transportation.

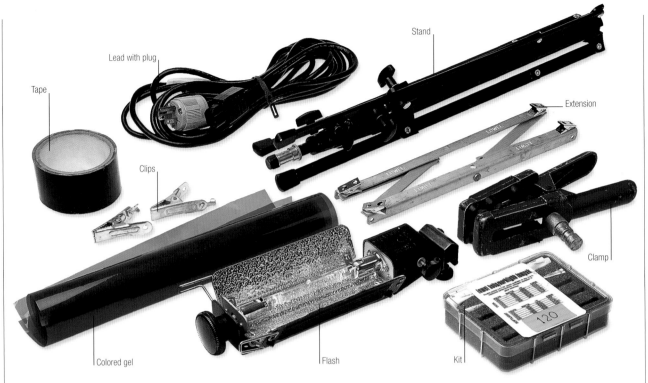

Tape

Lead with plug

Stand

Extension

Clips

Clamp

Colored gel

Flash

Kit

Lighting kit
If you're using lighting on location a kit like the one shown here isn't just a good idea—it's a necessity. Tape, clips, clamps, extentions, and spare stands and cables can be pressed into use to secure your equipment, stave off disaster and provide support where needed.

Mini slave flash
Even a pocket-sized flash unit can add useful fill-in lighting for spontaneous portrait shots.

Battery light
Portable tungsten lighting kits provide another option for the portrait photographer on the move.

Stand bag
Even heavy-duty stands collapse into fairly compact spaces, but if you wish to keep your lighting rig portable, a stand bag is a sensible investment. Alternatively, soft and hard cases are available to take up to four sets of stand and lamphead at the same time.

Makeup for photography

The vast armory of cosmetics enables you to enhance some features, and suppress others, while at the same time helping to create a specific aura. In addition, makeup for photography has its own rules and needs.

For beauty shots, makeup is an integral part of the photography. It and the lighting go hand in hand; one complements the other. In general, makeup for the camera is usually more pronounced—that is, more definite—than the styles applied for normal, everyday occasions. However, exactly how strong the makeup is depends very much on the style of lighting. A well-diffused light needs stronger makeup than does a spotlight.

The aim, as with most general makeup, is to enhance the best—or at least most striking—features of a face while suppressing the less attractive ones. High cheekbones tend to be valued in beauty shots and can be made even more striking by applying highlights above and shadows below. Or close-set eyes can be made to seem farther apart by extending the eye shadow outward. In a professional shoot, the makeup is planned with the lighting in mind. So if a high frontal light is being used from just above the camera, then the top of the cheekbones, ridge of the nose, and forehead will automatically be given highlights. At the least, they will need makeup to make them less shiny (unless a wet look is the idea).

Each individual face benefits from certain specific makeup techniques, and most models know which effects suit them best.

Sequence of applying makeup

Eye makeup begins (1) after the basic skin makeup has been applied with some highlighting to the inner areas close to the nose. To widen the appearance of the eyes, shadow is brushed on first at the outer corners (2), followed by the upper lids (3) and under the eyes with a finer brush (4), in both cases with stronger application toward the outside, for the same reason. After this, a highlight is applied on the upper lids right up to the eyebrows to give a more open appearance (5). Mascara follows, first at the corners (6), then the lower lashes (7), and finally the upper (8).

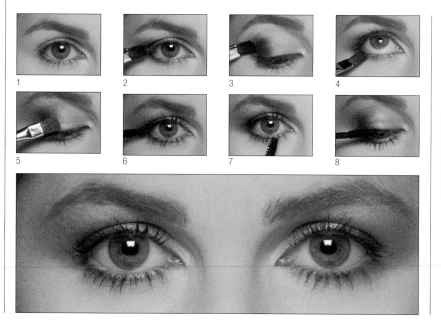

1 2 3 4
5 6 7 8

Makeup and lighting

The more diffuse, the stronger the makeup should be. Conversely, a bright spotlight, giving hard-edged and deep shadows, calls for more restrained, even bland, makeup (but a spotlight would be a rather dramatic, unusual choice for beauty lighting). Axial lighting from a ringflash around the lens is completely frontal, so flat and shadowless, and needs the strongest makeup of all.

Professional models, by the nature of their job, rarely have "problem" faces, but if you are choosing a female face for a beauty shot, look for the following: fine bone structure, a balanced facial outline with small chin, unblemished complexion, unobtrusive, straight nose, and eyes set relatively well apart. Skin blemishes can be concealed with strong foundation makeup and well-diffused lighting. Always apply make-up under the exact lighting that you will use for shooting. Then the highlights and shadows can be matched to the illumination.

1

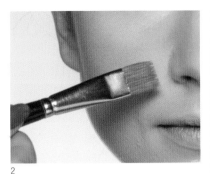
2

3

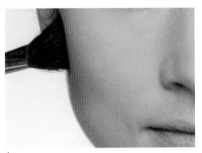
4

Skin

 Basic makeup begins with a moisturizer, then foundation (1), which gives a basic surface for everything that follows, adds an overall color, and smooths the skin texture; this is applied with a sponge pad. Highlight is then applied with a brush (2), blending well, and this helps to give a basic shaping, lightening those areas where shadows fall naturally, including under the eyes, below the lower lip, and under the base of the nose.

After this, powdering (3) helps to set the foundation and remove shiny highlights (which the camera would emphasize). Shading with another brush (4) refines the shaping of the face, here at the sides and under the cheekbones, but very subtly. Finally (left), lipstick is applied—but with a brush for complete accuracy of line.

Lighting for beauty

Strong shadows generally work against a beauty treatment, and the general principle is an enhanced version of basic lighting shown on pages 44–45. The position of the light is very important:
☐ overhead for naturalness
☐ frontal to reduce shadows (particularly under the eyebrows, nostrils, and lower lip)
☐ symmetrical, in line with the camera, for a balanced effect across the face.
Shadow fill comes from two white panels on either side and a reflector, either white or covered with crumpled foil, held by the model to light up the underside of the chin and nose. Beauty lighting is nearly always in conjunction with specific makeup, and the only way to ensure the perfect combination is to apply the makeup under that lighting. For convenience, move the reflector panels away while applying makeup, and make the final adjustments to these once the model is made-up and dressed.

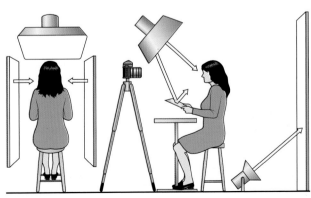
Setup 1 Setup 2

Digital retouching

This is post-production makeup, capable of effects both subtle and obvious, with the advantage that you can work precisely on the final result— on the image, not the face.

Retouching the photograph is a standard procedure in any kind of portraiture that aims for an idealized result—as is the case with fashion and beauty, for example. For the majority of photographs of people, it is less so, if at all, simply because it alters the reality of the shot. However, there may be special cases when you do want to make some changes to the complexion, eye color, hair, and so on. There is an issue of integrity here, as well as the risk that by perfecting things to an extreme you may end up with doll-like features.

At the time of shooting, briefly consider the retouching possibilities, as it may be more effective to eliminate a blemish, for example, by digital procedures later rather than by adjusting the lighting or applying makeup. With this in mind, once you have transferred the image to an image-editing program such as Photoshop, Step One is to assess it and decide exactly and in advance what should be altered and to what extent. Image editing is open-ended, so you do have to set your own limits, not only on the grounds of realism but also in terms of how much time to spend retouching. Make an overall assessment of the entire face, then zoom in and scroll through everything at 100% magnification.

There are two methods of retouching, and both involve the use of a soft (that is, feathered) brush to avoid defined edges to the retouched areas. Follow the checklist here. One is direct, one-step brushwork, which would be useful for, say, removing a spot, freckle, or pimple. The aim here is to substitute the surrounding color and texture of skin to the blemish, and this makes the cloning tool (rubber stamp) the normal procedure of choice. We will look at this in hands-on detail on the following pages.

Beauty retouching checklist

Complexion		
texture (smoothness)	eyebrow definition	**Chin**
color	eyeliner	dimpling
shininess	eye shadow	under-chin shadow
blemishes		
wrinkles and lines	**Mouth**	**Hair**
	lipstick color	tidiness
Eyes	lip gloss	extent (hair loss)
brightness	teeth whiteness	facial hair
catchlights	teeth regularity	color
color		highlights
eyelash definition	**Nose**	
mascara clumping	shadow irregularity	
	nostril hairs	

The second method divides the retouching into two steps—selection and alteration—and is more suitable for color changes to large skin areas and for effects that are measurable. In a masking layer (Quick Mask in Photoshop), brush over the area that you want to change, then convert this to a selection and apply changes using Curves, Levels, or the HSB sliders.

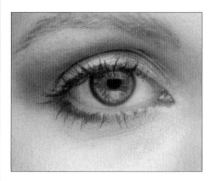

Small lines

The image-editing operation here is to remove those fine lines under the eyes, which are still evident after makeup and photography.

Blending in

Normal skin texture is now reapplied to the filtered area with a clone brush, taking its samples from the area just above the cheekbone, which has few blemishes. The retouched area is blended into the original first by darkening the layer using Curves, then by reducing the opacity to 67%.

Mask painting

For procedural effects, the first step is to brush in the areas over which they will be applied, in a masking layer which will then be saved as a selection.

Final

Finally the lines have been all but eliminated, while maintaining a realistic texture. The opacity blending of retouched and original layer is a matter of personal judgment.

Duplicate layers

For the finest blending control, two duplicate layers are made, one for the operation and another as backup. This offers an extra level of control by varying layer opacity, with the original maintained as the background layer.

Median filter

A median filter with a wide radius replaces the lines with the most typical pixel color from within that radius. Now, the effect is too smooth to be realistic.

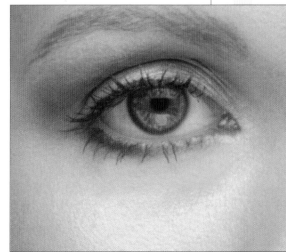

Retouching brushwork

Because digital-imaging tools are so closely modeled on real painters' brushes, effective retouching depends very much on dexterity, making practice essential.

In the old days of portrait photography, retouching was a great skill. A good retoucher, and there were specialists at this, was effectively a painter in the traditional sense, applying dyes and pigments to prints with a range of camel-hair brushes, sponges, swabs, and sometimes an airbrush powered by compressed air. It's no coincidence that these artists' tools are reproduced digitally in image-editing programs. The great advantage of digital retouching over the brush-and-paint variety is simply that you can undo mis-strokes and mistakes. This does not lessen the skill needed, but it does make the apprenticeship much easier. Nor do you have to concern yourself with the reaction between the paint or dye and the surface of the print—in digital retouching there are no textures or blobs.

Portraits are the most demanding of subjects in photography to retouch, partly because human skin is very subtly shaded, and partly because as observers we are highly attuned to the nuances of facial appearance—most people will quickly notice a blemish on someone's face, even if it is just a pimple or a shaving nick. Retouching is usually about removing these things and perfecting skin texture. Above all, it must be undetectable in the final image.

Brush sizes

A typical face contains a very large range of textural detail, from open skin areas (low contrast, absence of detail) to very precise features such as eyelashes. Vary the brush size according to the level of detail, as shown here. Actual pixel width depends on the size of the image—these are the recommended settings for a high-resolution 50-megabyte RGB picture.

Wrinkles
Tightly packed wrinkles demand a low brush size and a steady hand.

Eyelashes
Use as small a brush as possible in areas of intricate detail.

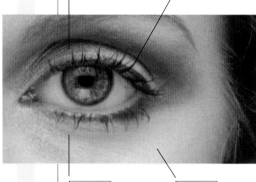

Skin details
For bigger areas that need retouching, use a medium-sized brush with a softer edge.

Larger skin areas
Open skin areas, with less texture and color detail, can be retouched using broader strokes.

Two-pass retouching

Using a close-up of the same face as on the previous pages, the exercise here is to remove a small mole, only just visible by its elevation. The easy technique is to tackle first the mole highlights with a clone brush set to "darken," and then the mole shadows with the same brush set to "lighten."

Because imaging tools are designed to imitate real brushes, pens, pencils, airbrushes, and so on, it's easy to forget that there are in fact no physical constraints. The more familiar you become with an image-editing program, the more likely you are to develop your own individual techniques. Nevertheless, fluid, natural brushwork is the basic skill to develop, and the more practice you put in, the more naturalistic your retouching will look. Begin with simple exercises on a blank screen, concentrating on different types of stroke, from short to long and from thin to broad, including applications of single dots of varying size. If you use a stylus with graphics tablet (*see below*), practice increasing and decreasing the flow by means of pressure. Move on from this to practical exercises in skin retouching, using copies of any face close-ups that you have in your files.

Graphics tablet for full control

Mouse, trackpad, and button are the usual computer solutions for moving the cursor around the screen, but to get the full benefit of the retouching tools available in an image-editing program, the device of choice is a cordless stylus and graphics tablet. The area of the tablet represents the screen area and the tip of the stylus moves the cursor. Pressing down on the stylus activates the tool selected. You can configure the setup so that increasing pressure on the tip makes the tool behave in an even more brushlike fashion, such as increasing the flow of "paint" or broadening the area of the brushstroke. This is an essential computer accessory for anyone who intends to work seriously on computer images.

▼ Graphics tablet
The conventional mouse simply doesn't have the finesse required for professional retouching. A graphics tablet offers more precise control over brush dynamics.

Cloning variations

☐ **Brush size** Match the size approximately to what you are trying to correct or replace.

☐ **Feathering and fading** Keep soft for complexion, tighter for details such as eyes and eyelashes.

☐ **Percentage** 100% cloning gives immediate full replacement and is standard. If the effect looks too striking, consider more than one application at a reduced percentage. The disadvantage is that this softens definition.

☐ **Color** To avoid altering the tone, restrict the cloning tool to one quality, such as hue, color, or saturation.

☐ **Two-pass technique** One way to deal with pronounced texture, such as deep pores or raised spots, is to clone from a selected smooth area, first as "lighten" to reduce the shadowed sides, then as "darken" to reduce the highlights. Doing this in two passes increases your control over the final effect.

☐ **Alignment** In aligned cloning, the distance and direction between source and target stay the same, which gives a natural-looking replacement from the source area. However, if you have only small patches of clear skin as your sources, it may be better to switch to nonaligned, in which the source remains the same. This runs the risk of creating an identifiable pattern.

Digital manipulation

Moving beyond retouching to outright manipulation is not to everyone's taste, but here anything is possible, the only barrier being your judgement and the sitter's willingness.

Post-production improvements are not limited to cosmetic effects of texture and color. This being digital, much more can be done, and the full scale of alterations possible is such that every digital photographer needs to make a conscious decision about how far to go. As we hope we've demonstrated already, digital photography doesn't end with the shooting, and at the very least images need to be prepared and edited, even if only for color, tone, sharpness, and so on. Image-editing, in other words, doesn't have inherent limits.

By shifting not just the colors and tones of pixels, but large groups of image pixels themselves, you can alter shapes, and if you apply this to portraits you have the opportunity to alter people's appearance and expressions. Heighten the cheekbones, widen the eyes, slim the hips? It's all possible, and perhaps not surprisingly this is becoming something like standard practice in public relations and in celebrity photography. There is,

Making use of assymmetry

Starting point
The original image, full-face, softly lit, and unretouched.

Duplicate and flip
While faces are in principle bilaterally symmetrical (mirrored left and right), individually there is always some difference. As a first step to recombining the two halves, a duplicate layer is flipped horizontally.

Selecting one side
Concentrating on the key elements for recognition (eye, nose, mouth), one side is selected by mask painting. The soft edges of the selection are located mainly in open areas of skin, which will facilitate blending.

arguably, little difference between Botox injections to "improve" the face, and the same effect created less expensively with a distortion tool in Photoshop. Both are artificial tricks.

Distortion is the principal technique, and there are several tools and procedures, some needing more technical expertise than others. The type of software known as a distortion brushing engine allows intuitive freehand work and is easy to start with, although mastering its subtleties takes practice. As a general rule, a large brush size relative to the image and a low percentage of strength will give more natural, smooth results. And remember how little it takes to change a facial expression–whether of muscles in real life or pixel-pushing on the computer.

In this example I've used displacement maps because they offer control and repeatability. A displacement map is a guide that tells the software how much to move which pixels–mid-gray not at all, black the most (in Photoshop, 128 pixels in any direction). Expression is complicated and subtle, and nearly always needs experiment. For all the effort of setting up displacement maps, they provide this, and it is always worth trying different percentages of movement and judging the effect by how much it appears to alter the expression–and by extension the mood of the person.

Changing the eyeline

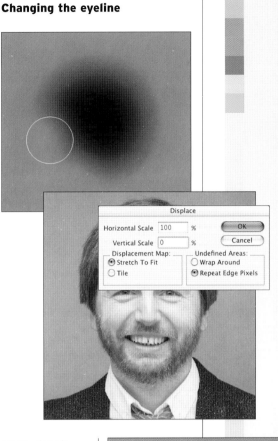

Moderate horizontal shift
A large diffuse circular area over the center of the face is retouched to leave the left outline of the face relatively undisturbed while the rest is shifted left (positive horizontal displacement).

Knock out the selection
The selected area in the upper flipped layer is deleted, leaving a soft-edged hole which reveals the original image underneath—and so a combination of two identical halves.

Combining the opposite half
By knocking out half of a duplicate of the original image, and overlaying this on the mirrored image, the opposite halves are combined—a second, strikingly different symmetry.

Indirect gaze
The progressive shift of pixels to the right has the effect of making the pupils appear to be directed slightly to the right of the viewer, reinforced by the general rightward warping of the face.

Changing the background

Digitally separating people from their surroundings demands careful technique, particularly for the outline of the hair, but once done enables the background to be adjusted, even changed completely.

This is a major procedure, but is performed routinely at a professional level in advertising photography. The obvious advantage is that you can save time and money by shooting in one accessible location, and then digitally substitute a more exotic or hard-to-guarantee background. Less heroic procedures involve cleaning up the existing background or removing parts of it. If you do undertake this procedure, be prepared to spend time and skill on making the results believable.

The key to all of this is making an accurately outlined selection, and the human figure is one of the most challenging subjects for the procedure, mainly because of the hair. There are several techniques for making a selection in an image-editing program like Photoshop, each with advantages and disadvantages. In cases where the characteristics of the outline vary from one area to another, you may find it best to combine two or more of these techniques. They include paths (good for clean outlines, but no use for

Overlay for interaction
The work of this scientist researching immunology was on the scale of electron microscopy, and to combine both in one image, the micro image was copied . . .

. . . microscope image of nerve fibers was inverted and blended in Lighten mode. As electron microscopes image in monochrome, the initially colorless layer was given slight hue adjustment.

. . . into one layer and blended so that it appeared as a projection—a kind of virtual screen to which the subject could point. Using black as a convenient background, the layer containing the original electron . . .

fuzzy detail), freehand lasso tool, mask painting, and smart selection tools, such as Photoshop's Magic Wand). Smart selection is any kind of semi-automated process in which you click on an area (of the figure or the background) and the software then searches for other similar pixels. How similar depends on a range setting that you give it. This is particularly useful in situations where there is an obvious contrast between figure and ground, and even more so when the background tone and color are fairly even.

In Photoshop you can convert a selection into a mask, and vice versa, at any time. A masking layer, in which the mask is usually given a strong color (you decide), enables you to paint the selection by hand. This is useful for creating a selection from scratch, or for retouching one made in the standard way.

The hair is almost always the arduous part to outline, unless it is very smoothly shaped and has no loose ends. Using any of the above conventional selection techniques, you have three basic choices. One is to make the selection outline around the hair fuzzy, by feathering it. This is a quick-and-dirty procedure that will work only if the figure is small in the frame and there is little detail visible. Another is to resculpt the hair to eliminate the fine strands, but it runs the risk of looking artificial. The third is simply to zoom in to 100% or even 200% magnification and work your way slowly along the outline—a painstaking and lengthy procedure.

▲ Center of the galaxy

The subject of the portrait was a Nobel Prize winner specializing in the study of the galactic center. This image was taken in HCN radiation of the black hole in the central cavity. It was presented simply as a backdrop, rescaling a cutout image of the professor and adding a drop shadow for realism.

▷ Cleaning up

Two Tokyo designers with one of their products, furniture based on transparent elastic membrane. The nature of the chairs made an all-white background an obvious choice, but the location was far from ideal—the designers' own atelier. However, knowing that the black-clad figures and the chairs could be outlined digitally later made it feasible to go ahead and shoot anyway.

Knockout software

Developed primarily for portraiture, this specialized class of professional-level software enables the most difficult outlines to be traced for background removal.

There are two major problems in extracting an object digitally from an image and placing it in a new setting—and the human figure exhibits both. One is fine, attenuated detail—hair in this case—and the other is edge reflection of background color, which you'll find on the rounded surfaces of smooth-skinned limbs.

The solutions are not simple, either technically in the software or in terms of the skill needed by the user, but they are available in the form of knockout, or extraction, software. Two principles are involved. One is a variable fuzziness to the outline so that it can deal with different degrees of hardness. The other is a way of calculating the color influence that the background has on the edges of the figure, then storing this information and applying it to whatever new background you choose.

The learning curve is steep, which makes it important to decide whether or not the benefit will outweigh the cost. In other words, will you make sufficient use of this software, and are you prepared to learn the minimum necessary? There is a threshold of believability below which results are unacceptable, and this applies particularly to the outline of the hair.

Fortunately, Photoshop now incorporates knockout software in the form of the Extract procedure, which enables you to experiment at no extra cost other than your own time. More sophisticated programs, notably Corel Knockout and Extensis Mask Pro, can produce highly effective results in slightly less time, but these also demand more effort to learn.

Extraction problems
Even the most experienced Photoshop artist would find this cutout a challenge using manual methods. Hair, particularly when it comes in soft curls, is almost impossible to select correctly. Photoshop's Extract command might be able to cope, but in this case the artist reached for Extensis Mask Pro.

Using Mask Pro

Mask Pro uses an intelligent "Magic Pen" to separate areas of high contrast, and provides users with "highlighters" which can be used to define areas to add to or exclude from the final selection. With this done, Mask Pro goes to work using color matching and color decontamination algorithms to decide which elements need to be extracted. The final result is a clean cutout made in minutes, rather than hours. There will still be some adjustments to be made once the selection is placed on the new background, but the hardest part has already been done.

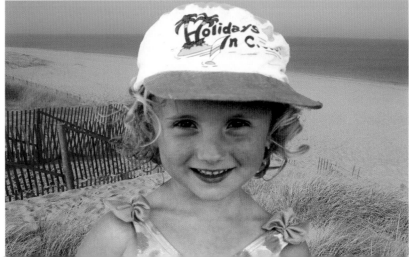

Post-production color

The place for final assessment and fine-tuning of color is the computer, using image-editing software. First establish reliable viewing conditions.

Under lighting conditions that you know and have tested, and with the relevant camera settings adjusted correctly (white balance, exposure, and, if available, tone control and hue control), you should get almost exactly what you want. However, it's often difficult to make an accurate judgement from the camera's LCD screen, and there may simply not be enough time. In addition, there are any number of other reasons for wanting to make color adjustments later, on the computer.

Before all else, you should calibrate your computer screen for viewing photographs, and the most important procedures are to set the gamma correctly and to set the color balance to neutral. Gamma affects contrast and is a measure of the range between highlights and shadows–the higher the gamma, the higher the contrast. Color balance is the overall bias of hue.

Almost all computers now include within the operating system a method of calibration, usually accessible through the Control Panel, and this procedure relies heavily on your visual judgement. A more objective and sophisticated method uses a device that attaches to the screen and measures the color output directly.

Display setup
The setup for a monitor display varies according to the computer's operating system. The example here below, from left to right, is the setup sequence for an Apple Cinema Display and OSX. Follow the advice supplied with your computer.

As active-matrix flat screens are taking over from CRT (cathode-ray tube) monitors, precise image judgement by eye relies very much on your line of sight being perpendicular to the display. You can test this with any image by moving your viewpoint an inch or two from side to side. For a more reliably accurate view of the color and tone, step back from the screen or reduce the size of the image displayed.

Camera manufacturers supply editing software (some at extra cost) that offers color adjustment, although most people who regularly use an image-editing program such as Photoshop will use that.

Viewing conditions

Keep ambient lighting low and consistent, so that your color and brightness judgement is not affected by the surroundings. If necessary, place a hood over the screen to block out bright lights or reflections.

Bit-depth

8-bit per-channel color is standard in digital photography, also known as 24-bit color because of the three channels used—red, green, and blue. Some cameras allow capture at a higher color fidelity, typically 12-bit per channel, or 36-bit overall. 8-bit is so-called because it has 2^8 (that is, 256) levels of brightness for each color channel. These multiply to give 16.7 million identifiable colors, within the range of discrimination of the human eye. 12-bit, however, has 4096 levels and billions of colors, 16-bit (48-bit overall) a staggering 65,536 levels, and while the difference may not be noticeable when printed or displayed on the screen, the image *will* maintain a full range of colors after you have made color adjustments in Photoshop. In other words, 8-bit is as good as you need for viewing, but higher bit-depths are important if you are going to make alterations.

Color space

Color space, also called color gamut, is a description of the full range of colors that a particular device, including a monitor display, can achieve. Digital cameras use RGB, but within this there are different types, such as Adobe RGB (1998), Apple RGB, ColorMatch RGB, and sRGB IEC1966-2.1. Wider gamuts like Adobe RGB (1998) are useful if you are likely later to make color adjustments, for the same reason that a higher bit-depth is useful—you are less likely to lose color values in the process.

Bit-depth damage
This is what a well-exposed photograph looked like in RGB Levels when imported into Photoshop, and the contrast-lowering curve that was then applied to it.

Even this modest operation is sufficient to damage an 8-bit-per-channel image (24-bit overall). The loss of color information is obvious in the gaps.

The same operation performed on a 16-bit-per-channel image (48-bit overall). The image is undamaged.

Color adjustments

Skin tones are among the most recognizable colors to the human eye, and so are critically judged, but image-editing tools give you fine, delicate control.

Color is used here in its widest sense, including the level of brightness. There are a number of different ways of defining color, and an image-editing program such as Photoshop offers a choice of procedures. Some are better suited than others to certain adjustments.

A color mode is a way of dividing the qualities of a color, and the most widely used in digital photography is RGB (red, green, and blue). Almost any color recognizable by the human eye can be created by mixing these three primaries. In an image-editing program, RGB mode allocates each of the three to a separate channel. If you can see that the skin tones in a picture are too red, for example, then this is a straightforward mode in which to make the adjustment—lower the Curves or Levels in the red channel, or raise them in green and blue.

Tailor-made for skin tones
This third-party software iCorrect Professional, used as a plug-in, provides intuitive correction, and contains built-in color profiles of skin tones, making it particularly useful for portrait correction.

Adjustment methods
Photoshop offers three principal controls for altering colors; two of them have an automatic correction option. Each offers a different approach, and certain images will respond better to one or the other, depending on what you want to change.

Curves
Running from shadows to highlights, the curve can be bent at any point˚—or at several points—to alter brightness in different parts of the image. You can use it on the entire image or channel by channel to work on individual hues (here RGB, but also CMYK and Lab—see opposite).

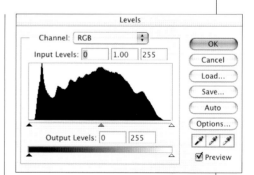

HSB
The Hue/Saturation controls are basically HSB sliders. As well as the Master set of all colors shown here, individual hues can be selected, and within these you can use the dropper tool to fine-tune your selection before making changes.

RGB Levels
Basically an adjustable histogram that runs from dark on the left to bright on the right, three sliders underneath enabling you to set the black and white points, and to alter the overall brightness between them.

A less frequently used but very valuable color mode is Lab, in which the color is divided between lightness (L) and two color scales, green-to-red (a) and blue-to-yellow (b). The great advantage of this is that you can alter the brightness without making any changes to the hues.

The color mode generally considered closest to the way we see is HSB– hue, saturation, brightness (also known as HSV, with brightness referred to as value). Hue is what most people refer to simply as color, the quality that distinguishes red from orange from yellow, and so on. Saturation is intensity, also known as chroma, and brightness (value) speaks for itself.

You also have choice in the method of adjustment, The simplest is the slider, which makes an overall change across the range–uncomplicated and easy to use. Levels, which in Photoshop can be used in RGB, Lab, and CMYK modes, allows you to make changes to the histogram (see page 68). Curves can also be used with these modes, channel by channel, and is the most sophisticated and flexible method. It permits changes to be concentrated in particular zones of the brightness range–you could, for example, reduce the red in just the darker skin tones, leaving the highlights untouched.

The original image
In whichever color mode this image is stored, it will be a composite of three or more color channels. Using Photoshop, the image can be split back into these separate channels (see below) for fine-tuning.

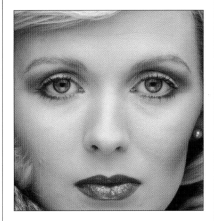

CMYK
This color mode, used in printing, divides the image into four channels, three of them the complementary of RGB and the fourth Black.

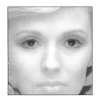

Cyan · Magenta

Yellow · Black

RGB color
This is the most commonly used mode, and the standard for digital cameras, and splits the image into three channels.

Red · Green

Blue

LAB color
Underexploited but very useful, Lab divides the image into a Luminance (brightness) channel and two color scales—a, from green to red, and b, from blue to yellow.

A-lab · B-lab

L-lab

Lighting for effect

Most photographs of people set out to give either a flattering or an accurate representation of what they look like and what they are doing. Sometimes, however, there is a need for a dramatic, unusual or graphically striking treatment.

It's one of the cruel ironies of photographing people that you can spend years learning to light them in a flattering way, but the one time your lighting is actually noticed is when you do something a bit unusual. Anyone who has held a torch under their chin to frighten a child on Halloween knows just how easy it is to use light to achieve a desired effect. As photographers, we can use five attributes of lights to make our pictures that little bit different.

Quantity. There is no limit to how many or how few lights you use, nor is there any limit to the degree by which you deliberately over- or underexpose the photograph.

Quality. Lights can be hard or soft, and once the conventions of portraiture are replaced by the creative possibilities of lighting for effect, you can experiment with both extremes of the light quality scale.

Direction. We mentioned above the idea of the horror style of lighting. Effect lighting lets you explore every possible way of pointing your lights to make an interesting image. Uplighting is always unusual.

Color. Some of the most effective lighting techniques involve using colored gels over your lights. A mixture of strange colored and uncolored lights in a single frame can give your work a lot of impact, although there should be a solid reason for it to avoid looking like no more than a gimmick.

Type. The most common lighting for adding atmosphere and mood to still photographs is flash, but a mixture of flash and ambient light gives you all sorts of creative possibilities.

With these five methods of giving your lighting dramatic effect, there is no limit to what you can achieve. You can use one or all of them at the same time, but the notion that "less is more" should never be far from your thoughts. It can be very effective to combine a more conventional style of lighting to all or part of your subject's face while using one or more of these effects on the background and the rest of their body.

When you want drama in your work, one of the most important things to avoid is light bouncing around where you don't want it. Many of the best studios are either so large that there are no near surfaces off which light can

Gem sleuth
This New York gem collector and dealer specialized in tracking down rare specimens, and while he was happy to be the subject of an article, he did not want a completely recognizable portrait. The solution was a silhouette with an added focussing spot directed on to his eyes. The position, with hands holding a glass and a stone, created a shadow on the lower part of his face.

accidentally bounce, or they are painted entirely matt black for the same reason. If you don't have a studio, it's well worth exploring the idea of getting some black "subtractors." They are used in exactly the same way as their more conventional cousins—white, gold, and silver reflectors—except that they provide a surface that deliberately absorbs light . You can buy black panels, make them out of painted styrofoam, or simply use big sheets of black cloth to do the job (velvet absorbs the most).

Architect
Kengo Kuma, a well-known Japanese architect, had just completed a building which featured slatted illuminated panels on the sidewalk outside. Printed with Japanese characters, these were illuminated mainly from the ground, an unusual and striking direction when used for portraits.

Children

Children have an entirely different reaction to the camera than do adults; realize this and you are well on the way to taking great photographs of them.

Children are reputed to have a shorter attention span than adults, although experience photographing them says that this isn't completely true. Children simply show their boredom more openly, so as photographers we need to develop strategies for lengthening their attention span. Keeping a child's interest for long enough to shoot good photographs is a skill in itself. Some studio photographers who specialize in child portraiture invest in an array of attention-getting props, such as glove puppets and soft toys. Sometimes, it's best to rely on somebody or something to keep the child busy and occupied, to give you more time to set up and get the shot.

Spontaneous play
In an Italian piazza, this boy was entranced by the hordes of pigeons fed by tourists, and stepped away from his father to walk among them, oblivious to anything else. An ordinary moment but special for this child, as his expression shows.

In the digital age children usually know that you have an LCD on the back of the camera and they will try to see what you've taken after every single frame. Managing to keep them on your side by showing them pictures while avoiding their desire to see every frame as it happens is a tricky balance, so it's important to set down some rules about when and how many images they can see. It's only when you talk to the individual child that you can judge this balance and an amount of negotiation is often required.

Tip

When shooting children, it's important to get the camera down to their level for the vast majority of shots, and this normally means being on your knees at the very least.

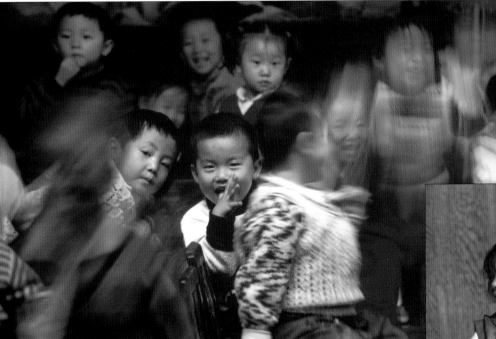

School recess

Recess at a Chinese village school. The photographer captured the bustle by using a tripod and slow shutter speed (a half-second), shooting when two of the children, more interested in her than in their classmates, paused to look.

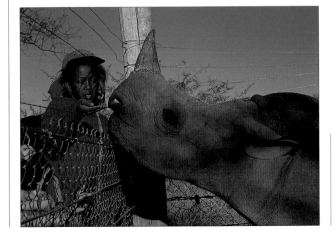

Rhino

At a privately run game reserve in South Africa, the owners arrange school trips to familiarize city children with animals such as this rhino, whose mother had been killed by poachers.

Children's day

In this Japanese children's festival, they are dressed up in traditional costume and are then taken to a shrine.

Children at play

Toys and games, when they are apt, can absorb a child's attention so fully that they enter another world, and you then have the freedom to shoot as you please.

As advice, it may be something of a cliché to hand a toy to a child, but new things and new games do tend to engage children more completely than they do adults. These are not necessarily predictable, and you may easily find yourself suggesting something that the child finds supremely uninteresting, but when children do get involved in the thing at hand, you have a distinct window of opportunity for photography.

The reaction usually goes in one of two directions. One is when children want to show off the toy, dress, or whatever, and that's when you can engage

Presents
Just unwrapped, a set of toy spectacles and stethoscope were a Christmas present that, for a few minutes at least, beat everything else on offer for this young girl. The moment for shooting her unselfconscious smile was very short-lived.

Queen of hearts
The occasion was a children's party in the City of London, and the theme the Mad Hatter's tea party from *Alice in Wonderland*. Dressed as the Queen of Hearts, this girl has thoroughly entered her part, reviewing the chaos around her with a regal disdain.

them directly, face to camera. Inevitably, this moment does not last, so speed in shooting counts. Don't fiddle around with the camera settings; as a default, use auto-everything. It's better to catch the moment with an exposure or color deficiency than to have nothing; remember that many digital faults can be repaired later. You may be able to enhance or prolong this kind of occasion by turning the camera around and showing the shot to the child, but this may just as easily backfire. In the case of the girl with the plastic spectacles, I did just that, fortunately after I already had a couple of good shots. Much as she liked the picture, she was enough of a young lady to censor any more such childish portraits of herself.

The other, opposite reaction is total absorption in the alternative reality of play, to the point of ignoring all else, including you and the camera. This, as long as it lasts, is ideal for almost-candid photography. You should be able to pick and choose your angle and moment. A longer focal length will keep you from intruding on the game.

▽ Insect playground
Slowly overcoming a natural reaction of repulsion to this tame tarantula, a young boy finally takes the challenge and strokes it with one finger. The spider completely absorbs the attention of everyone, even at the expense of the world's largest insect clinging to the man's sleeve.

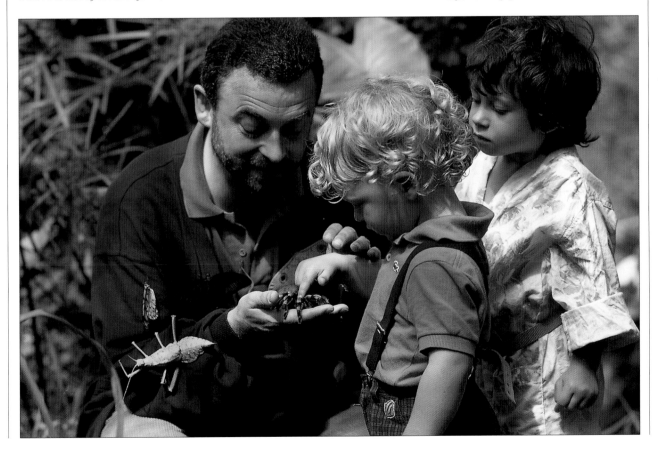

Daily **Life**

Photography is constantly challenging many of the old assumptions about what a portrait is, or could be. Digital photography is taking this even farther. Ultimately, this is because the continuing improvements in the technology of cameras, lenses, film—and now sensors and digital processing—make it easier to create images. But what is fascinating is the wide-ranging effects that this has had on the way we see images. In other words, simply because we can now photograph people successfully in all kinds of situation, a freer, looser style of portraiture has become accepted.

People are not by nature static subjects, and so the ideal camera is one that responds quickly and flexibly. In the earliest days of portrait photography, there was never enough light and the recording medium, daguerreotypes and glass plates in particular, were pitifully insensitive. The result was constant compromise —arranging sitters in poses that they could hold for a minute or more (sometimes even headrests were employed out of sight) or firing pyrotechnic banks of lighting.

Since then there has been a history of improvement, but never quite reaching the point at which photographers could simply relax and shoot. There was always some workaround needed for a problem of lighting, shutter speed, depth of field, color accuracy. And in fact, some of the formality of the traditional posed portrait was in response to this. Being still and under the photographer's direction guaranteed a sharp, well-focussed image.

Modern cameras, and in particular digital ones, have broken down many of the restrictions in photographing people. Small, light, and fast, the early 35mm cameras made candid, unplanned photography possible, and now digital cameras have extended the situations in which you can shoot. This is because they respond so flexibly and show you the results instantly. Flesh tones, lighting, and shutter speed are no longer a problem.

As we will demonstrate, digital cameras score through their ability to process the image in any number of ways. Even though the sensor array is inherently less sensitive than average film, this is misleading. The signal can be enhanced, meaning that if you set it to high sensitivity you can do things that were virtually impossible before. Ultrahigh-speed color film had quite nasty image qualities, including muddy shadow tones and a fat grain size that all but ruined the picture. The worst that a high-sensitivity digital image suffers from is noise— a random pattern of wrong pixels which becomes obvious only in enlargement—and this can be repaired digitally.

So now you can photograph people under almost any circumstances, day or night, outdoors and indoors, without having to stop and adjust the situation or lighting. Given this, what defines a portrait? Clearly it no longer has to take place in a studio or be formally arranged. It can have movement, action, and interaction. You can shoot so that it appears candid. Indeed, by giving up the role of director-photographer and becoming an observer, following your subject, you are in effect shooting candidly. Portraits have never been so easy and varied.

The natural approach

You can often capture an unselfconscious spontaneity by ignoring preparation, control, and considered lighting, instead encouraging your subject to do whatever comes naturally.

Pictures like this appear to have no technique at all, and I say that without a hint of criticism. It is indeed the very idea—to be artless, spontaneous, and natural, a moment caught among many, with no obvious interference on the part of the photographer. There are no frills, no lights, no posing—at least on the face of it.

But of course there is technique, every bit as much as in the posed portraits in the first section of the book. The difference is that the techniques are different, having been shifted from those of production, organization, timing, and reaction. They are downplayed in the image, and the result is that everything looks casual and uncomplicated: the person just happened to be there with that expression and that gesture, and the camera just caught it.

And that may very well have been the case. Or, the photographer may have loosely set the scene in motion, then stepped back and retired, as it were, from view, observing a more-or-less natural situation. The key to all of this is having sufficient confidence in your own ability to compose and focus quickly, and this is something you can actively practice and improve (no need to worry about wasting film; just check and delete).

Begin by making a quick assessment of the general setting in terms of the lighting and the background. Are they consistent and suitable? If not, consider changing the location, particularly if your subject is going to move around. Check that the camera settings are right for this: sensitivity, white balance, shutter speed, and aperture.

▽ Instant reaction

At a small engineering workshop in Athens, I waited until the welders had finished. They looked up, one with a huge grin. That was the moment to shoot, with no delay.

Daily **Life**

Photography is constantly challenging many of the old assumptions about what a portrait is, or could be. Digital photography is taking this even farther. Ultimately, this is because the continuing improvements in the technology of cameras, lenses, film—and now sensors and digital processing—make it easier to create images. But what is fascinating is the wide-ranging effects that this has had on the way we see images. In other words, simply because we can now photograph people successfully in all kinds of situation, a freer, looser style of portraiture has become accepted.

People are not by nature static subjects, and so the ideal camera is one that responds quickly and flexibly. In the earliest days of portrait photography, there was never enough light and the recording medium, daguerreotypes and glass plates in particular, were pitifully insensitive. The result was constant compromise —arranging sitters in poses that they could hold for a minute or more (sometimes even headrests were employed out of sight) or firing pyrotechnic banks of lighting.

Since then there has been a history of improvement, but never quite reaching the point at which photographers could simply relax and shoot. There was always some workaround needed for a problem of lighting, shutter speed, depth of field, color accuracy. And in fact, some of the formality of the traditional posed portrait was in response to this. Being still and under the photographer's direction guaranteed a sharp, well-focussed image.

Modern cameras, and in particular digital ones, have broken down many of the restrictions in photographing people. Small, light, and fast, the early 35mm cameras made candid, unplanned photography possible, and now digital cameras have extended the situations in which you can shoot. This is because they respond so flexibly and show you the results instantly. Flesh tones, lighting, and shutter speed are no longer a problem.

As we will demonstrate, digital cameras score through their ability to process the image in any number of ways. Even though the sensor array is inherently less sensitive than average film, this is misleading. The signal can be enhanced, meaning that if you set it to high sensitivity you can do things that were virtually impossible before. Ultrahigh-speed color film had quite nasty image qualities, including muddy shadow tones and a fat grain size that all but ruined the picture. The worst that a high-sensitivity digital image suffers from is noise— a random pattern of wrong pixels which becomes obvious only in enlargement—and this can be repaired digitally.

So now you can photograph people under almost any circumstances, day or night, outdoors and indoors, without having to stop and adjust the situation or lighting. Given this, what defines a portrait? Clearly it no longer has to take place in a studio or be formally arranged. It can have movement, action, and interaction. You can shoot so that it appears candid. Indeed, by giving up the role of director-photographer and becoming an observer, following your subject, you are in effect shooting candidly. Portraits have never been so easy and varied.

The natural approach

You can often capture an unselfconscious spontaneity by ignoring preparation, control, and considered lighting, instead encouraging your subject to do whatever comes naturally.

Pictures like this appear to have no technique at all, and I say that without a hint of criticism. It is indeed the very idea—to be artless, spontaneous, and natural, a moment caught among many, with no obvious interference on the part of the photographer. There are no frills, no lights, no posing—at least on the face of it.

But of course there is technique, every bit as much as in the posed portraits in the first section of the book. The difference is that the techniques are different, having been shifted from those of production, organization, timing, and reaction. They are downplayed in the image, and the result is that everything looks casual and uncomplicated: the person just happened to be there with that expression and that gesture, and the camera just caught it.

And that may very well have been the case. Or, the photographer may have loosely set the scene in motion, then stepped back and retired, as it were, from view, observing a more-or-less natural situation. The key to all of this is having sufficient confidence in your own ability to compose and focus quickly, and this is something you can actively practice and improve (no need to worry about wasting film; just check and delete).

Begin by making a quick assessment of the general setting in terms of the lighting and the background. Are they consistent and suitable? If not, consider changing the location, particularly if your subject is going to move around. Check that the camera settings are right for this: sensitivity, white balance, shutter speed, and aperture.

▼ Instant reaction
At a small engineering workshop in Athens, I waited until the welders had finished. They looked up, one with a huge grin. That was the moment to shoot, with no delay.

Trappist monk
The style of this portrait is as plain and direct as the circumstances in which the Trappist order of monks live in the Belgian monastery of Orval, famous for its beer. Father Lode, in charge of brewing, stands calmly in the cloisters of the thousand-year old building.

Assessing the setting: checklist

☐ **Lighting** Is it consistent, or a mixture (eg sunlight and shade)?
☐ **Color balance** Make sure that the white balance setting is appropriate for the scene and lighting.
☐ **Light level** Is it sufficient to allow a reasonable shutter speed (say 1/100 sec) at the widest aperture (say, f-2.8)? If not, set the ISO sensitivity to allow these.
☐ **Background** Is it uncluttered or will it be out of focus when the subject is sharp? Are there any overbright areas against which the subject will be silhouetted?
☐ **Focal length** Anticipate which you will need.

Harvest
In the Valley of Roses, near the town of Kazanluk, Bulgaria, ninth-grade teenagers from nearby schools harvest the world's most expensive roses. These are the Damascene roses that set the standard for the perfume industry's rose oil. One of the girls pauses briefly from her work to talk to a friend.

Street photography

Take your subject out on to the street to interact with the neighborhood, in the portrait version of a classic reportage way of shooting.

In reportage photography, the street is the arena for a wide range of human activity, and street photography, as it is generally known, is one of the standard working procedures. Equipped with the minimum of equipment—a shoulder bag, camera and a lens or two (or a single zoom)—the idea is to explore on foot, photographing life on the pavement, in open-air cafés, markets, parks, and so on. Nothing is preplanned; you rely solely on your powers of observation and anticipation, and on luck, to find interesting images from ordinary situations. This is urban life, but there is a consistency to it around the world, even if the people themselves may be different.

The emphasis is on three things—being unobtrusive, spotting potential pictures in advance, and shooting quickly—and while these are techniques designed originally for candid shooting, you can also use them for a kind of freestyle portraiture. For a change, even with a planned portrait, have your subject simply walk around, shop, take a coffee, whatever comes naturally.

◀ Nice market
A shopper at the morning market in Nice strikes a pose as he jokes with one of the stall-holders off-camera. The camera viewpoint was an elevated walkway, and I was looking for just such moments of conversation and interaction with a medium telephoto lens.

▶ Cuzco
Three Peruvian children step up to the edge of a road as they prepare to cross. Seeing them approach, I had several seconds to prepare as they climbed the few steps.

The idea of being unobtrusive rather than drawing attention to yourself is so that the people in shot will not be looking toward the camera or otherwise reacting to you, the photographer. This is a simple enough aim to achieve: don't festoon yourself with obtrusive equipment; dress down; don't stand in the middle of the road; and keep moving around. Anticipating a good shot is down to staying alert and constantly checking potential views, bearing in mind focal length (*see box*). Above all, because there is often a constant flow of people and traffic, the opportunity for a clear shot may last for only a second or so.

You must be prepared to react instantly—which of course is where the camera's automated settings come in: autofocus, auto exposure, matrix/multi-pattern metering, and automatic white balance.

Tip

If you really don't want to look like a photographer but still need to carry a reasonable amount of equipment, buy a cheap small bag with a strap for the cameras and lenses. The cheaper and more ordinary it is, the less noticeable you will be.

▶ **Morning coffee**
In the town of Aix-en-Provence, tables from the surrounding cafés fill one of the old squares. The aim was an overall view, and so I was using a wide-angle lens (20mm efl). The moment was made by the animated gesture of the man as his friend leans back and looks at the sky.

Focal length and distance

Familiarize yourself with the combination of focal length and distance that will give you the basic kinds of framing, from full-length to close-up head shots. This will speed up focal length selection so that you can simply raise the camera and shoot.

	20mm efl	35mm	50mm	100mm	150mm	200mm	400mm
Standing/ horizontal format	1.5 m	3 m	4 m	8 m	12 m	16 m	32 m
Standing/ vertical format	1 m	2 m	3 m	6 m	9 m	12 m	24 m
Two people/ vertical format	1.5 m	3 m	4 m	8 m	12 m	16 m	32 m
Head and shoulders/ vertical format	NR	NR	1 m	2 m	3 m	4 m	8 m
Head shot/ vertical format	NR	NR	0.75 m	1.5 m	2 m	3 m	6 m

[NR - not recommended]

Wide-angle techniques

Provided that you take care to avoid the characteristic distortion, a wide-angle lens has two valuable functions: it places the person firmly in their surroundings, and it draws the viewer into the scene.

Whether you use fixed lenses or zooms, the focal length you choose for any particular shot makes a substantial difference, not only to the character of the image but also to how you prepare for it. At its simplest, changing to wide-angle or standard or telephoto is a framing convenience: from whatever distance you happen to be standing, changing the focal length either expands the view or drops in on it. Zooms have a clear advantage here: they enable you to react much more quickly than by stepping back or forward.

But there's more to it than this, particularly in a situation in which there are people moving around. With a wide-angle lens, you will be taking in much of the immediate surroundings, as these examples illustrate. This goes hand in hand with the camera position, because in order to partly fill the frame with a figure, you will typically be shooting from a few or several feet away. This naturally makes you fairly obvious to passersby, and one problem is having someone who is not your subject in frame and staring at the camera. The way to avoid this is to raise the camera only immediately before you shoot, then lower it.

Alternatively, if you have the camera to your eye and the image framed, you could simply wait it out, or even briefly lower the camera, glance to one side so as to divert their attention, then shoot.

The value of wide-angle for photographing people in an interesting setting is precisely related to this close shooting. This kind of image has an involving character that projects the viewer into the scene. The photographer is clearly in the middle of things, a style sometimes known as "subjective camera," which conveys a sense of being there and of activity.

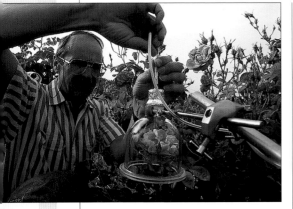

Deep focus
A scientist near Grasse in the South of France, conducting a "headspace" experiment with a rose, analyzing the scent it gives off. A 20 mm efl lens was completely stopped down to ƒ22 for maximum depth of field and full use was made of this to get the rose as close as possible to the camera, while keeping the image of the man sharp.

Aiming off

One difficulty, although only an occasional one, is that people can also see you easily—and that may make it impossible to get a second natural-looking shot. Quite frequently, you will get only one opportunity, and if you fluff it there's nothing for it but to move on. A wide-angle lens, however, can help in this. If you compose the view so that the person you want to photograph

is off-centered, it will appear as if you are aiming the camera to one side. On occasions, you can continue shooting as much as you like within a few feet of the person.

Shooting without viewing

If you are using a wide-angle lens, then critical framing may not be necessary. With practice, you should have a fairly good idea of what the lens will take in without actually looking through the viewfinder. If so, you can shoot on auto-focus without appearing to use the camera—hold it rather lower than usual, and look away as you squeeze the shutter release. The composition may be a little sloppy, but that may matter less than getting the photograph.

Near-far composition

"Near-far composition" is a term that was coined by the great landscape photographer Ansel Adams to describe photographs which exploit the strong perspective of a wide-angle lens: close objects loom much larger than distant ones.

Designating focal length

Over many years of familiarity with 35mm film, the standard in photography, we have all become accustomed to using the lens focal length as a shorthand description of the general image qualities of wide-angle, extreme wide-angle, telephoto, and so on. Therefore, 35mm means "slightly wider view than standard," 20mm means "extremely wide coverage with distortion." However, these numbers apply strictly only to a 35mm format, measuring 24mm x 36mm. Because most digital camera sensors are smaller than this, the equivalent focal lengths are shorter. It has become customary in photographic parlace to continue using the old 35mm figures, while appending "equivalent" or "efl" (equivalent focal length). This is the system that is used here.

Morning market
Although not as extreme a use of near-far composition as the rose picture opposite, this scene taken in a French market is composed and the aperture adjusted so that vegetable produce fills most of the frame while maintaining depth of field. The framing of the shopper and the vegetables connects one with the other.

Aiming off
An old man reads a guide to the great medieval cathedral at Chartres, standing close to a font. I liked the sense of empty space and silence. The way to handle this, it seemed to me, was to place the man almost at one edge of the frame to let the stone space dominate.

Medium telephoto

Longer focal lengths make for objective across-the-street compositions in which your subject can go about without the distraction of a camera constantly hovering nearby.

Whereas shooting wide-angle draws you closer to people and delivers busy, engaged images, longer focal lengths separate you from your subject, both physically in distance and in the sense of involvement. As with wide-angle focal lengths, telephotos are important less for the fact that they save you the effort of moving closer to your subject than for the distinct graphic style that they bring to an image. When you are photographing people, these longer lenses also have the added advantage of keeping you, the photographer, out of the way. This makes it relatively easy to shoot without being noticed.

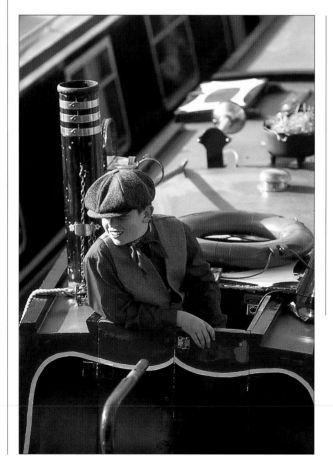

50mm efl has always been considered standard as a focal length (*see box on page 81*), and anything noticeably longer than this—basically from 80mm upward—is classed as telephoto. The longer the focal length, the more pronounced the characteristics described here. Because of the narrow angle of view, less of the surroundings are in the picture, and if your subject is some way in front of the background, another factor will come into play—shallow focus. The longer the focal length, the shallower the depth of field, meaning that when you focus on one person in a crowd, those nearer and farther away will be out of focus. Stopping down to a smaller aperture improves the front-to-back sharpness, but rarely completely, and needs either a slow shutter speed or high sensitivity. There is nothing at all wrong with this, and selective focus (as it is also known) is valuable in that it enables you to separate a person visually from the surroundings.

Ultimately, a telephoto is a good method of focussing attention on your subject and removing the distraction of busy surroundings. In many ways this is opposite in

A reasonable distance
A 180mm efl lens offers this kind of framing from about 30 feet, which is far enough to shoot without drawing attention to yourself. This shot was taken from a footbridge.

character to the wide-angle style on the previous pages, and a major factor in choosing the focal length will be your preference for one or the other style of image. All telephoto portraits, as you can see here, tend to look more detached and less involved.

Shutter speed and camera shake

Long focal lengths magnify, and this applies to vibration as much as to the image. A common mistake is switching to a longer focal length without paying attention to the shutter speed that is set. As a rule of thumb, the slowest shutter speed at which you can safely shoot handheld is the reciprocal of the focal length. So, while 1/50 sec is no problem with a standard (50mm efl) lens, use at least 1/200 sec for a 200mm efl lens.

Defining "standard"

Wide-angle and telephoto have easily recognizable characteristics in photographs, but they exist on either side of a notional "standard" focal length. The logic behind this is that the image appears to have the same perspective and relationship between objects as it would to the naked eye. In fact, if you keep both eyes open, one to the viewfinder, the view and size of objects should be about the same (this is one way of finding the standard setting with a zoom lens). For the technically minded, this standard focal length is the same measurement as the diagonal of the sensor array.

Selective focus

Except in special circumstances when there is a good reason for trying to hold everything in the frame sharp, the usual focussing technique with a telephoto is to keep the aperture well open—perhaps a couple of f-stops less than full so as to keep the entire figure within the depth of field—and ensure the face is always sharply focussed. In vertical framing, if the camera has a choice of focussing areas, it's useful to select the upper one, as shown above right.

▲ Priority to the eyes
Shooting at dusk with a 150mm efl lens, there was little light, needing a full aperture of ƒ2.8, and so very shallow depth of field. At a distance of less than, 6½ feet (2 meters), the only sensible point to focus on was one of the boy's eyes, using the camera's upper focussing area.

▶ Compressing into one plane
A dressing scene for a television production of a historical costume drama. The moment was a natural, but was particularly successful with a telephoto lens, which kept the three figures in close relationship to one another.

Long lenses

The ultimate in objectivity, a long lens puts a distance between you and your subject, both literally and figuratively. It enables you to stand back and make detached, compressed-perspective images.

There is no clear division between medium and long telephoto lenses, but if you move along the scale of increasing focal length, there comes a point at which the effects are clearly extreme, akin to picking up a pair of binoculars. My own definition of a long lens is one which gives an image that reveals more than the eye can see. Eyesight works differently from the optics of a camera lens because it involves perception—and we can quickly change from taking in a very wide field of view to paying attention to a narrowly defined scene. Long lenses go farther, and as a result often deliver surprises. 300mm efl is at about the cusp of distinctly long telephotos.

All the characteristics, and difficulties, of telephoto lenses are exaggerated with these focal lengths. Used for people, particularly in street photography, they let you take remarkably close shots while staying well back (and often completely unnoticed). From about 26 feet (8 meters) with a

▶ **Filling the frame**

The subject was pockets of village life in the center of Athens, and a 400 mm efl lens was used here to compress the perspective and fill the frame with this old street (a shorter focal length would have included sky and other buildings). The shot was a matter of waiting for the right passerby—an old woman taking her cat for a walk.

400mm lens and a 24mm x 16mm sensor, you will have a frame-filling head shot. At full aperture, which is how these long lenses are normally used, the background will usually be completely blurred.

Small sensors boost the effect

At this stage in digital photography, most cameras' sensor arrays are smaller than the 24mm x 36mm format of 35mm film, while most SLR lenses were designed with 35mm in mind. Because the digital sensor uses a smaller area of the focussed image, the effect is a greater magnification, so that a 300mm lens used with a 16mm x 24mm sensor, for example, will behave as if it were 450mm.

Why telephoto?

The term telephoto is common currency for lenses that give the kind of image shown here and on the previous two pages: magnified, with compressed perspective and shallow depth of field. But in fact it refers to the most common design of long focal length lenses. In a simple, non-telephoto design, a 400mm lens would actually measure 400mm from its optical center to the back of the camera, where the sensor sits. Using multiple lenses, the telephoto design "folds" the path of light to make the lens smaller and more convenient.

Zoom ratios and magnification

Because a colon (:) is used by manufacturers to designate both the zoom and magnifying capabilities of lenses, there's scope for confusion. A 1:2 zoom can double its focal length, but this could be from 35mm to 70mm efl or from 100mm to 200mm efl. Magnification, on the other hand, always has the standard focal length as its reference point—50mm efl. A 400mm efl lens gives a magnification of 1:8, or 8x.

Finding a good camera position is critical, because you need clear space between you and your subject. In public areas, unless you shoot from an elevated viewpoint, you are very likely to have a flow of passersby interrupting the view. If you are able to shoot with both eyes open (a useful technique), so much the better, because you'll then have a little advance notice of an obstructed view, but do still be prepared for a proportion of wasted shots. One of the best ways of shooting is from somewhere that you can sit quietly for a while without drawing attention to yourself.

▲ Isolating the figure
In the rays of the setting sun, a Surinamese girl fishes in the river from a canoe. The shot was taken from a boat about 300 feet away, using a 400mm efl lens. Compression helps to make the shot by making the deeply shadowed forest appear large, so that the attention is drawn to the girl.

▼ Sikh guards
The typically shallow depth of field with a long lens used wide open can be used, as here at a parade in the northern Indian city of Amritsar, to convert foreground and background into a color wash, which frames the figures.

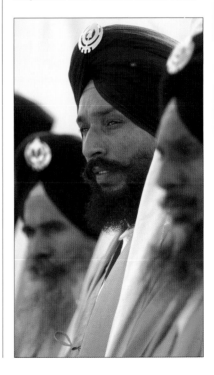

Workplace portraits

Work is what fills the greater part of most people's lives, and the majority take some pride in what they do—a quality that you can bring out, and that can add depth of expression and meaning to a portrait.

▽ Objects and person
Gun proofing workshop in the City of London. The aim was to show an interesting collection of the weapons with the Proof-master, and the solution was a wide-angle shot framed vertically with the arms in the close foreground.

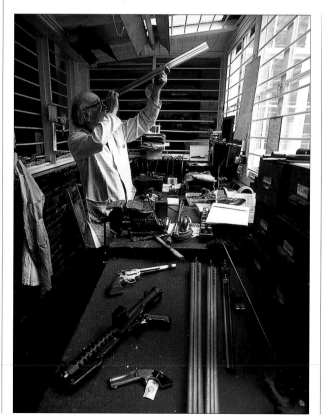

The work that people do offers some outstanding opportunities for making portraits, although it is often ignored or avoided by photographers thinking in classic terms of portraiture. Although it's a natural response in setting up a session to take someone away from what they are doing and set aside time just for the photography, you may find it more convenient and more successful to shoot when people are occupied with their regular work. This is, after all, what we do most of the time, and while some jobs are more interesting visually than others, you will always have a ready-made setting and activity. In a way, photographs of people at work bridge the gap between posed and spontaneous portraits—they have an element of each; a development of the contextual portrait with the naturalness of daily life.

Unlike a personal moment in which someone might easily object to being photographed, work is generally treated as an open activity. In fact, far from intruding, a photographer is often welcome. When people take pride in their work, they are naturally flattered by the attention of someone who is seriously interested in what they are doing. The exceptions are when the photographer gets in the way of a job and interferes with it or slows it down, and if the person you are photographing actually considers the work demeaning—this latter can be a problem in urban ghettos and some poorer countries. Usually, however, if you make a reasonable approach you will get a sympathetic, if occasionally puzzled, reaction. Or, of course, you may not even need to ask, but just shoot as you would a street scene.

What can make this subject rewarding to photograph is that work provides the occasion for people to exert themselves, physically and mentally. All jobs have their particular rhythm and complexities. Much of this is unspoken, but gives you the opportunity to explore.

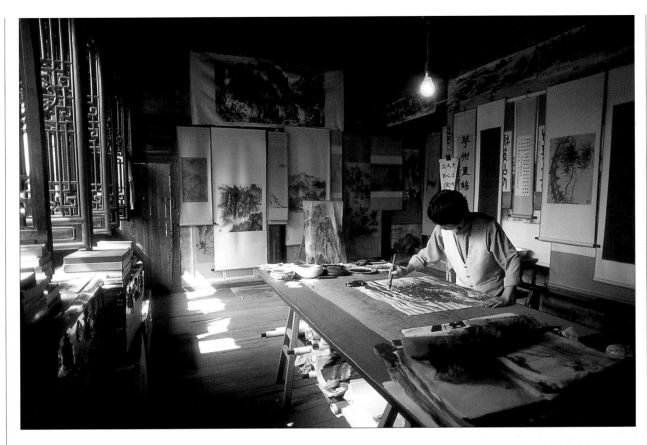

Calligrapher
A different objective from the image on the opposite page, even though both make use of wide-angle composition. Here, the studio of a Chinese calligrapher was full of atmosphere and detail, and the shot was composed to show as much of it as possible, with the man relatively small and off-centered.

Detail work
The subject is a Tokyo jewelry designer. The close detail nature of her work made this kind of framing a natural choice, using a medium telephoto lens. Backlighting simplified the outline and activity, with the exposure adjusted to lighten the shadows and show the face in what would otherwise have been a plain silhouette.

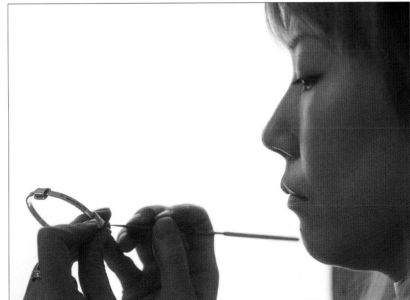

Work as the subject

The procedures of individual work can add a new dimension to portraiture. By focussing on the physical aspects, you can make the image informative and explanatory.

Not all work is visually compelling, hence the inherently boring nature of pictures of business meetings and people sitting at computer workstations–an increasing phenomenon. However, work that is in some way physical, and even more so if it contains an element of craft, has the possibility of itself becoming the subject of the photograph–rather than being simply a setting for the person. The result will still be a portrait, but with the flavor of reportage. Instead of the person pausing to be photographed, he or she remains involved in the work they are doing.

This kind of image is, however, far from being spontaneous, even though the final image will, or should, look natural. To photograph a sequence of work effectively, you need to know in advance the logic behind it. This is partly to ensure that everything in the shot is accurate; it is all too easy to set something up, introduce props, or interfere in other ways that will make a good composition, only to discover later (and too late) that things are not normally done that way and that the setup is a nonsense to anyone familiar with the procedure. Some people can be overcompliant in letting a photographer re-arrange their workplace. Rule one is to observe without suggesting, by watching quietly and then asking the person to take you

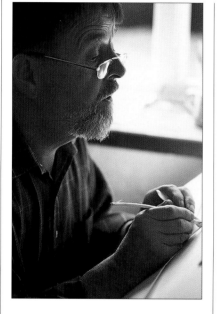

▲ Scribe

Using a traditional quill pen made from a goose feather, and hand-prepared parchment, a modern-day scribe works on a specially commissioned version of the New Testament. Hands and face, with an expression of complete concentration, reveal the essence of this painstaking work.

▶ Modeling

In the model-building department of a theatrical costumiers, a model maker molds a head for an exhibition at which period costumes will be displayed. The head itself is striking enough to catch the attention, but the reference photographs and camera viewpoint make sure that the process is explained instantly.

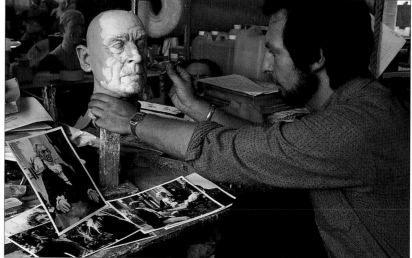

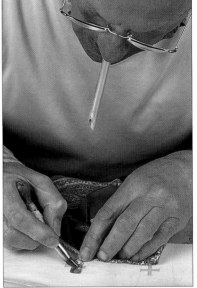

Rose petals
During the annual rose harvest, sackloads of petals are dumped on the warehouse floor of a perfume distillery each morning and are then scooped into buckets ready for distillation. After a recce the day before, this shot was planned in advance, and photographed from a catwalk for a strong, overhead view that fills the frame with color.

Gold leaf
Working in the same scriptorium as the scribe on the opposite page, the chief designer of the project applies wafer-thin gold leaf to part of the parchment that will become an illuminated title page. Another view of detailed concentration.

through the process. The other reason for taking time to prepare is so that you can find a clear, coherent view, and while you should rightly be cautious of moving a vital piece of equipment out of the way, there is no point spoiling the image by not shifting furniture that serves no useful purpose. Ask first.

Once you have understood the work procedure, you can then if necessary ask for pauses, which may well be necessary if you are using a slow shutter speed. If you close in on a pair of hands, for instance, the ideal depth of field may call for a small aperture and so a slow shutter speed. An alternative is to set a high ISO sensitivity and accept some random noise in the image.

Case study: **Work**

The procedures of individual work can
add a new dimension to portraiture.
By focussing on the physical aspects,
you can make the image both
informative and explanatory.

◀ **Ship painter**
Three photographs
that show the sequence
of exploring a single
situation over a short
period of time. The scene
of a painter working
on the side of a liner
had obvious graphic
possibilities because of
its simplicity. The first
shot concentrates on the
man's actions, holding on
with one hand while he
leans to apply paint.

▶ His shadow,
however, has
potential, being
cast conveniently
underneath. For the
second shot, I stepped
back and found a lower
viewpoint to frame
everything as neatly
as possible—man
positioned between
two letters, all of the
shadow in frame,
and man and
shadow separated.

▲ But then, perhaps this was just too neat, and for
the third and final shot I let the shadow tell the
story of what was happening, with just the two feet
dangling from above.

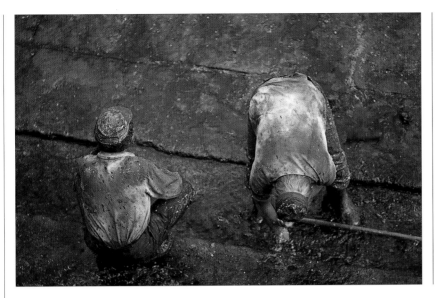

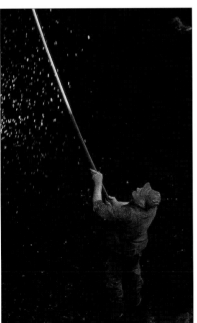

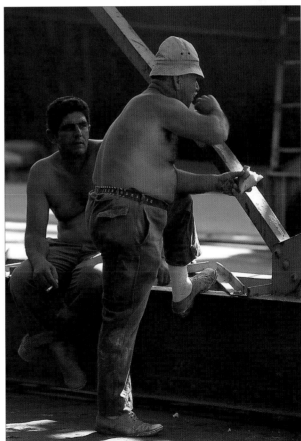

Propeller
Workers were cleaning around the blades of a ship's propeller, which suggested a spiral structure to the image. I wanted to wait until the three men were evenly spaced and all visible in the spaces divided by the blades.

Blending with the dirt
Cleaning old vessels in a dry dock is filthy work, and after a while the workers acquire a camouflage-like coating, from this angle seeming to blend in with the browns and grays.

Scaling
Working on the floor of a dry dock, one man scales the side of a ship, the rust falling like a shower. I waited until he moved to a part where the sunlight captured the debris.

Lunch break
A pause for a smoke and a snack gave the opportunity for another type of image. What caught my eye was the play of light, the cool shadows, and the figure of the man.

Low light

At the cost of noise over the image, digital cameras make light work of shooting by available light and fading daylight. Sensitivity and color balance can be altered from frame to frame.

Photographing unobserved in low light vastly extends the opportunities–to indoor settings and evening. Technically things may not be as bright as you would like, but then neither are you so obvious as a photographer. Although the range of film speeds still exceeds the sensitivity range of a digital camera's sensor, shooting digitally is generally easier and more convenient. There are two main reasons for this: first, the sensitivity in many cameras can be switched from the standard ISO 100 to a higher one on demand, and second, the white balance can be adjusted (*see pages 98-99*). Check first what your camera is capable of in these two areas of sensitivity and color balance. Less expensive models offer fewer options and tend to automate whenever possible.

While flash is made for just these situations, and can be extremely useful, it can drown out more delicate available light, such as candles, weak lamps, and anything in the distance. It also announces the photographer's presence, which runs counter to the idea of candid photography.

◢ Backlight for higher shutter speed

Even with an overall light level that is too low for normal shooting, it is possible to shoot against the light and use a higher speed. In the case of this man in an Amsterdam bar, the shutter speed was 1/60 sec, and while the shadow areas are dark, all that counts is the edge of the subject—front of face, hand, and the glass of beer.

▷ By candlelight

Candles can give a very evocative, atmospheric light, but using them for photography creates a massive difference in brightness between the flame itself and what it illuminates. The eye can accommodate this fairly well, but the camera's sensor cannot. It is essential to expose for the subject and let the flames overexpose. Even so, light levels are low and very red (low color temperature). For a shot like this, at the Shwedagon Pagoda in Yangon, Burma, a tripod is important—then wait until the subject is still.

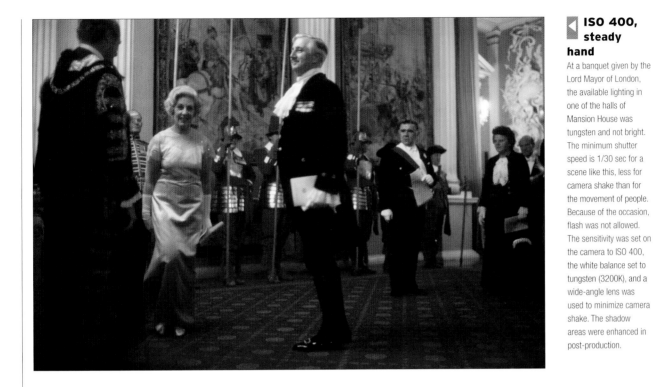

ISO 400, steady hand

At a banquet given by the Lord Mayor of London, the available lighting in one of the halls of Mansion House was tungsten and not bright. The minimum shutter speed is 1/30 sec for a scene like this, less for camera shake than for the movement of people. Because of the occasion, flash was not allowed. The sensitivity was set on the camera to ISO 400, the white balance set to tungsten (3200K), and a wide-angle lens was used to minimize camera shake. The shadow areas were enhanced in post-production.

The technical problem with low-light shooting is that the signal from the photo-sites on the sensor has to be amplified in order to be read, and this also amplifies the faults. Adding flash solves that problem, but also changes the quality of the light and can destroy the atmosphere of the shot. There are technical solutions that offer greater sensitivity, though these are applied mainly on high-end models, but fortunately noise can be reduced in post-production, in an image-editing program (*see box*).

Spotlight

This peepshow at the Museum of American History was illuminated by a display spotlight in an otherwise dark hall. This kind of light gives harsh contrast and is difficult to expose effectively; the trick is to make the composition mainly out of highlights. By waiting until the boy was in a particular position, with some light falling on his face, a just-readable image was made. White balance was set at tungsten, and sensitivity at ISO 400, but later boosted in image-editing by using Curves.

Repairing fixed-pattern noise

Noise from slow exposures is in a fixed pattern of pixels, and a highly effective way to reduce it is to follow the shot with a second image at the same shutter speed, but completely black (cover the lens for this). This "black" frame will have the same pattern of blown pixels, and these can later be used as a template for restoring tone and color. There is more than one technique, but because the two images, normal and "black," are in perfect register, copying the "black" frame into an Alpha channel turns the noise into a selection. Apply this selection to the normal image, and make adjustments in Levels, Curves, or HSB.

Case study: **Coptic church**

The new freedom that digital capture brings to indoor situations could hardly be better demonstrated than in this sequence of a Christmas midnight mass at a Coptic cathedral.

Permission to shoot had already been requested and approved, with very few restrictions, but a series of flash exposures would have been far too intrusive. There was about a half hour to prepare before the archbishop arrived and the service began. I used this time to find out what would happen, where, and when—and also to check the technical conditions. With a mixture of fluorescent and tungsten light sources, I needed to fine-tune the white balance, using the Auto setting as a starting point. I also had to decide on the lowest sensitivity setting that would enable me to shoot handheld, yet still avoid camera shake. This turned out to be ISO 1250.

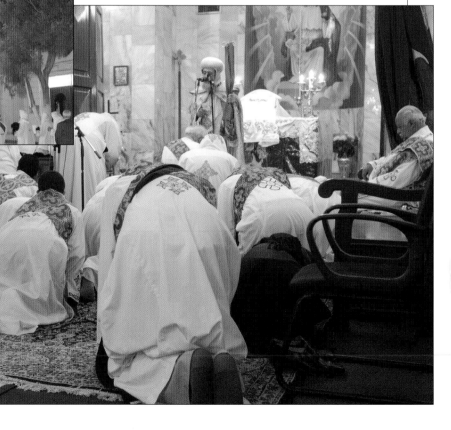

Procession
The archbishop's party enters the courtyard from his residence—an opportunity for an establishing shot of the cathedral. This is the one occasion for using supplementary flash.

Sermon
The archbishop's main address before the mass.

Incense
The archbishop completes three circuits of the interior of the cathedral, carrying incense.

Too late for some
One of the children finds that midnight is really time to sleep.

Cross
A member of the congregation reaches out to touch the cross as the bearer walks up the aisle.

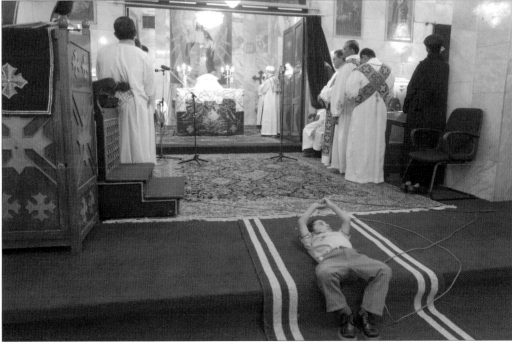

Skin tones and white balance

Keep the color of skin on target, even under the varying conditions of sunlight, shade, cloud, and low sun, by using the camera's white balance options and the histogram.

The range of color and shades of human skin is both strikingly broad and at the same time subtly differentiated, however much we may tend to think that our own family color is normal. First, though, a word about memory color.

This is an important concept in understanding what color is and how great a part our perception plays in defining it. As explained fully in another book in this series, entitled *Light and Lighting*, color exists only because the human eye recognizes it and interprets it. We discriminate certain colors better than others, meaning that they are more important to us and we are generally more familiar with them. For this reason, they are known as memory colors; we see and know immediately whether or not they look as we think they should look.

And why shouldn't they? The usual causes are color shift and wrong exposure, too much or too little. Neutrals are prominent memory colors—the various shades of gray, in other words—followed closely by skin. The eye makes an immediate, intuitive appraisal of a portrait in terms of color accuracy without analyzing the details. It looks right or wrong: too red, or tinged with green, or bluish. Note that this applies only to images, never to the

Levels

Channel: RGB

Input Levels: 0 1.00 255

OK
Cancel
Load...
Save...
Auto
Options...

Output Levels: 0 255

☑ Preview

Dark skin exposure

Automatic exposure tends to lighten dark skins. After you take the shot, check the image immediately for its brightness, ideally by looking at the exposure histogram.

real thing. Even if you see a face under colored light, your eyes will accommodate.

This is highly subjective. There is no measurement that will tell you what you don't already see, so it's perfectly reasonable to judge the result on the LCD display by eye.

If you have time, shoot a test frame and judge the color balance. Then adjust the white balance as necessary and according to the choices that your camera offers. If there's no time for this, choose Auto or one of the other basic settings and plan to do any fine-tuning later in an image-editing program. Exposure matters in this case because of its effect on color saturation. Underexposure will exaggerate the color of lighter skins, while overexposure on darker skin will introduce highlight colors that you had not actually anticipated. Look at the histogram to see where the tones fall (*see page 39*).

Close in for a test reading

This is suitable only if you have the time and opportunity. Use a longer focal length and frame the shot right in on the skin tones, excluding the background and clothing. Alternatively, use the center-weighted or spot metering if your camera has that choice. The result will be an average tone, which you will then have to judge in relation to the type of skin—it will be too dark for a black skin, but too light, for example, for a pale Scandinavian skin.

Dark skin exposure
To fix the problem in camera, reduce exposure by between 0.5 and 1.5 *f*-stops. Otherwise, use Levels in Photoshop to bring the shadows back in and take the highlights under control.

A case for center-weighting

With a head shot, center-weighted metering may be more accurate than multipattern/matrix metering, provided that you fill the central metered area with skin tone.

The moment

Through expression, action, and gesture, people present a constantly changing subject to the camera. Choosing and capturing the appropriate instant calls for judgement and fast reaction.

In unposed photography—candid photography, reportage, or whatever you care to call it—the people in front of the camera present a fluid situation. They move, they act, and they interact with one another, all without interference from the photographer. Inevitably, in any given scene that you frame, certain moments will simply make a better-looking image than others. They may be more interesting, more unusual, more dynamic, more graphic, or have any number of other qualities that you value highly. They make the difference between a so-so image and a compelling one that will stand the test of time.

The great French reportage photographer Henri Cartier-Bresson coined the phrase "the decisive moment" to describe this key quality in a photograph. In his 1952 book of the same name, he defined it as "the simultaneous recognition, in a fraction of a second, of the significance of an event as well as the precise organization of forms which gives that event its proper expression."

Such is the regard in which Cartier-Bresson is held, it has become a widely accepted ideal in the photography of people. It's also fair to mention that every so often some writer on photography tries to argue that it is an outmoded concept, but the reality is that professional photographers pay attention to the idea, even if they express it differently. Other photographers have challenged it with the idea of ordinary "in-between" moments, but not with any lasting success.

Indeed, one main issue is, who decides? There are two parts to photographing the moment: deciding what it should be, and capturing it. The two do not necessarily occur in that order, because while you may shoot carefully until you know that you have it, you can also shoot more freely and choose the key frame later in editing.

◀ Reaction shot

At a traditional broom factory in northern Thailand, I was arranging a set of these distinctive implements when this girl walked quickly behind me carrying some more (and probably hoping not to be part of the shot). There was no time to change settings, and hardly enough time for a single exposure as I swung round and panned the shot. It worked, but only just, at 1/100 second.

Gesture
Bathers at a hot spring in Tuscany on a Sunday afternoon. The chiaroscuro effect of the light and the color of the water combined made for a potential shot, but it called for something more from the bathers. I waited without anything particular in mind, until the woman reached out at the same time as the man turned to steady her.

Pattern and movement
Vietnamese girls dressed in the traditional *ao dai* at a statue-unveiling ceremony in Ho Chi Minh City, with a telephoto lens. While the girls were waiting, there were a number of opportunities similar to the smaller picture (left), but at one point two of them decided to shield their faces from the hot sun, creating quite a different—and strongly graphic—image. It was all the more interesting for not having any faces in shot.

Anticipation

The most important aid to knowing when to press the shutter release is being able to predict what will happen in front of you—meaning how your subject is likely to react.

As you saw on the previous pages, capturing the moment depends on two skills meshing perfectly. One is being able to react to it in time and accurately, the other is recognizing it as the moment. You can help both of these along if, in any given situation, you have a good idea of what is going on. If so, you stand a chance of being able to predict what will happen. This might be as simple as realizing that in a few seconds someone will turn around, or reach out for something, or start walking. In other words, anticipating the next move.

At root, this is not much more than a combination of observation and common sense, but to make it effective you need to sustain a high level of alertness, looking around your subject and guessing the often several options. One of the most basic situations in candid photography is a person walking and approaching. Which way will they go? Are they likely to turn at that corner, or enter that shop, or cross the road?

The second part is applying your prediction to the image, meaning that you also have to judge how the action or movement that you expect to happen will look—its visual effect. In the case of a person walking toward you or across in front of you, where would look best? Silhouetted against a bright patch of wall, or framed in a doorway, or perhaps entering an area of sunlight? These are all highly specific decisions that depend entirely on the situation. They will influence whether or not you shoot, when you shoot, and what focal length or camera settings you will need. The examples here are equally specific, but the principles stay the same.

▼ Sugarcane sellers

A simple matter of watching what was happening. Although I first saw the single boy holding sugarcane for sale by the side of the road, I quickly realized that he had a junior partner, and they would soon meet up—with the possibility of some interaction.

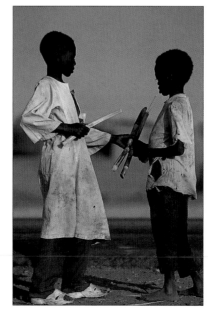

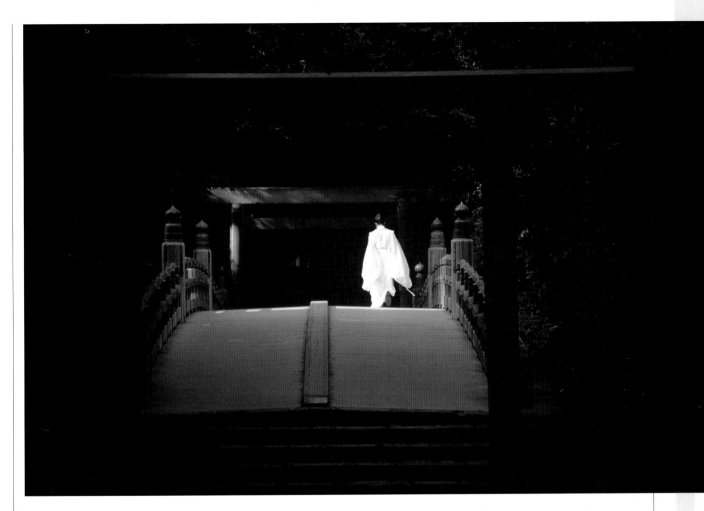

▲ Passerby #1

This wooden bridge in the forest at the Imperial Shrine at Isé, Japan, was no shot at all on its own, but I had spotted the patch of sunlight and realized that a figure crossing might make a good image at the moment of walking into the light. A few people crossed before the figure that I really hoped would appear—a Shinto priest in white robes. I spent part of the waiting time checking the exposure in anticipation.

▶ Passerby #2

In contrast to the image above, this shot would work without a passerby, but not as well. In particular, a figure would give the scale to this unusually massive door to the mosque at an ancient Indian city. It was predictable that people would pass frequently—I had simply to decide on the position (against the shadow at right would be clear and leave all of the door visible) and which person (I opted for traditionally clad).

Case study: **Looking for more**

Put several or many people together and you have a very different situation in which you have to play the part of stage manager and deal with group interaction.

More often than not, when photographing people you are faced with a situation in which you have an initial idea for the image, work on it until it seems you have what you want, but then stand back and think of what other opportunities there might be. This is often a matter of how much effort you are prepared to put into it. As an illustration of how the final shot can develop from a different beginning, yet within the same basic situation, this sequence was shot as participants in London's annual Lord Mayor's Show gathered.

First scene
Including the figure of a footman provides a counterpoint to the robed aldermen waiting to begin the procession.
The viewpoint was chosen to give a triangular composition, the apex being the feet nearest the camera.

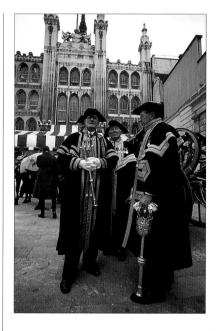

Vertical
I then looked for another treatment with the same wide-angle lens. The building behind looked worth including, and needed vertical framing, as from here the three figures appeared closer together. Not strikingly successful, so I switched to a medium telephoto.

Two-shot

A medium telephoto gave the opportunity to concentrate on expressions as the men talked—and on the anachronism of a cigarette set against the eighteenth-century costume. Although I was preoccupied with the faces, the ornamental maces had registered in my mind while I was composing the vertical shot …

Mace, gown, and gloves

Shifting the view down with the same lens, I realized that one of the silver maces was a miniature of the Tower of London. The image suddenly had the potential of being more iconic than I had suspected. The framing also happily excluded all tones and colors from the background other than the ornamental black and gold robes. Pity that the "Tower" was on its side.

Closing the sequence

Luckily, and without my asking, the alderman with the mace returned it to its upright position, and I had an unexpectedly concise image of the pomp and history of the City of London. Little surprise that from many hundreds of images on the assignment, this was the one used in the German magazine *GEO* for the title spread of the feature.

Sequence of action

Either because the window of opportunity is short, or because the activity builds up in front of you, some occasions demand a series of frames that you can edit later.

If you think of a person performing an extended action strictly in photographic terms, what you have is a slice of time that will potentially deliver one good image. It might last a few seconds, or up to some minutes. This time-slice is obviously related to one physical setting. One way of dealing with this is to anticipate the right moment and catch it, as we've just explored.

Dress parade
Photographing the complex process of donning the ceremonial uniform of the Greek palace guard, called *evzones*, I was looking for something more than a straight dressing sequence. The short "skirt" was an obvious anomaly when worn by these tough soldiers.

Another way to treat this period of time is as a sequence, shooting a series of frames that will cover it from beginning to end. There are two alternative reasons for doing this. One is a situation in which you know the start-point and end-point and so can be confident that you'll be able to shoot a certain number of frames between them, yet you don't know exactly how things will look. The other reason is that the sequence may be progressive in the sense that one action follows another and you are not sure in advance which one will make the best image.

Memory buffer and processing capacity

Digital cameras have a limit to the number of images that can be taken in quick succession. Unlike a frame of film which, once exposed, is moved along by the transport mechanism, each digital image has to be processed in some

way and then moved to the memory card. This is a potential bottleneck, which is partially relieved by a memory buffer in the camera—temporary storage for a number of images while they are transferred one by one to the memory card. Once you reach the buffer's limit, shooting will typically be disabled, meaning that you may lose the best shot. This is a particular concern if you are shooting at high resolution with various processing options turned on. For example, a buffer might hold six images and a 3-megabyte JPEG image take two seconds to process. In this case the entire buffer will take 12 seconds to clear, and while this is happening you should shoot at intervals no shorter than two seconds. But a 6-megabyte RAW image using proprietary compression and noise reduction could take 45 seconds to process and the buffer might be able to hold only three. This is for a Nikon D100; the figures for other makes will vary.

None of this necessarily depends on speed, and the two examples here have been chosen partly to make this point. In the case of the coach passing in front of the camera, the sequence took several seconds. The sequence in a Greek army barracks lasted a half hour. With rapid action sequences, you may want to consider using a continuous shooting mode if your camera allows it, but be aware of the limits for processing images. Although you can free up the memory buffer by checking and deleting images, there is not likely to be enough time for this. Normally, you would edit the sequence later. With a sequence that unfolds slowly, you will have the time to make decisions as you shoot, particularly about whether any new variation is an improvement over what you have already shot.

▶ **Lord Mayor's coach**

This was at the same occasion as the aldermen on the previous pages, and for a procession it was the key shot, of the newly elected Lord Mayor in the gilded coach, brought out once a year. Fortunately, I had an unobstructed view of this part of the route, close enough to fill the frame with the coach, using a wide-angle lens (20mm efl). A quick sequence, taken from when the coach was large enough and until it passed right by, gave a choice of four images, any of which could be chosen, depending on whether you were prepared to trade a view that shows more for one that concentrates on the essentials.

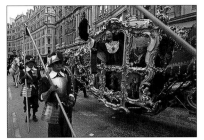

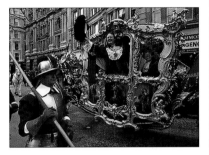

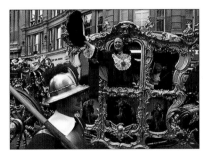

Framing the figure

The choice of how much and which part of the frame a person should occupy depends largely on their relationship with the frame and with their surroundings.

In terms of where to position your subject in the picture frame, tight compositions generally take care of themselves, especially when you match the format to the shape. We saw this in action with posed portraits in Chapter 1, and in street photography on pages 80-81. Closely cropped shots of a single figure tend to favor a vertical frame, whether the 2:3 proportions inherited from 35mm film and now used mainly in high-end digital cameras, or the "fatter" 3:4 format in most others.

Things get more interesting when you pull back so that your subject no longer fills most of the frame. Not only does the figure have to fit into the surroundings in a visual sense, it also has to have a considered position within the rectangular picture frame, by no means always in the middle. Design decisions enter the equation, and the smaller the figure within the frame, the more these matter.

The bull's-eye approach of placing the subject plumb in the center is absolutely safe—and not very interesting. In fact, symmetry and centeredness can be curiously unsatisfying, maybe because they are so predictable and static. Consider a face in profile in a horizontal picture frame. There will inevitably be empty space on one or both sides. Now, as the head in profile faces either left or right, so does the eyeline—an imaginary line following the direction of the gaze—and this creates a vector within the image. In design terms, it feels more satisfying if the head is off-centered so that any free space lies in front of it.

This is a standard solution, but not to be followed slavishly. If there is a sense of direction created by the way the person is standing, sitting, or facing, try framing so that they face from one edge into the frame. If there is movement, the case for doing this is even stronger.

Off-center
In these shots, one in the Carrara marble quarries overlooking the coast in Tuscany, the other looking out onto a south Indian temple town, the figure has been placed at the edge of the frame, looking inward, to direct the viewer's attention to the scene in front of them.

Letting the graphics decide

This is the same situation as the portrait on page 27, but the treatment has been determined by the diagonal pole of the large flag and the circular shape of the hat. The geometry of these two shapes directed the composition.

page 27

Standing stones

The subject, a scientist, suggested these standing stones in Wiltshire as a setting. Choosing a wide-angle treatment to include the landscape, the natural place for the figure was against one of the stones, continuing the circle's line.

The proud hotelier

The successful owner of the IceHotel in northern Sweden, photographed for a magazine feature. The hotel is built of ice and has been a hit with tourists. The entrepreneur needed no encouragement to be expansive and simply had to be placed in front of his invention—and slightly to one side.

Orientations

These diagrams illustrate how the most common tight portrait framings shape up. The less closely they match the camera's format, the more choice you have in where to place them—in the center, slightly to one side, more to one side, and so on.

Vertical format

single figure full-length | two figures full-length | head and shoulders | full face

Horizontal format

reclining figure | seated figure, knees raised | head in profile

Beyond this, look at working your subject into the design dynamics of the setting. If there is a strong diagonal, for instance, consider how the person might relate to that. If there is a natural frame within the picture, such as an archway, perhaps your subject would fit comfortably into that. Above all, try not to get fixated on just one or two ways of composing a picture.

Figure as accent

Pulling back so that people appear small in the frame does not necessarily make them appear insignificant, but rather shows them in a different context.

A tiny figure standing in or walking through a large space may seem at first glance to be less a portrait than a landscape, containing a punctuation. Sometimes, indeed, such a picture is conceived exactly as this, but it is also an interesting and restrained way of establishing a connection between people and their wider surroundings.

One thing that you are forced to abandon with this kind of extreme composition is identity. At this scale there is no question of showing who exactly the person is, unless the image is one of several in a picture essay (*see pages 152-155*) and you have already established their identity. Otherwise, the best you can hope for is a kind of general description based on clothes and action–for example, a farmer among fields, a worker in a large factory space, or a climber on a mountainside.

Used sparingly and printed large, this kind of composition has a high success rate, provided that the figure is both small and, paradoxical though it may sound, prominent. These figure-in-a-landscape images work precisely because they pitch a small human being against a sweeping, powerful location, so the extreme size relationship is key. And the figure must have sufficient contrast against the setting to be noticed.

Typically, contrast takes in the form of color difference or tonal difference–either dark against a light background or light against a dark background. It's of no use if the viewer misses the point, although a slight time delay in appreciating the figure will actually enhance the effect.

The principle of a delayed viewer response–taking a moment before the figure is spotted–is one good reason for using imagination in where you place the figure in the frame. Eccentric composition, meaning well away from the center, is definitely justified. The technique of framing so that the figure is moving into the picture from one side, as introduced on the previous pages, is particularly apt.

▽ Botero sculpture
In this picture of a bronze statue by the Colombian sculptor and painter Botero—one of his characteristically exaggerated rounded figures—the boy seated behind was included purely as a counterpoint, the size difference exaggerated by using a wide-angle lens.

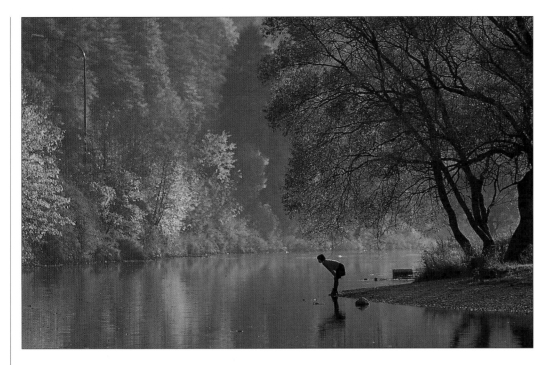

The assignment was a series of portraits around Belgium of a young Japanese poet, which made visual variety paramount—she would be pictured several times in the magazine feature. In addition to more usual close views, I tried this distant framing to make use of a beautiful riverside setting in the Ardennes.

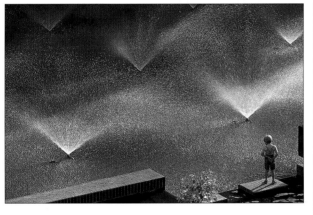

City fountains

Here, the geometry of inverted triangles, backlit by the sun, suggested a shot. It simply needed someone in frame, and the natural position was in the angle formed by the concrete blacks surrounding the pond.

Moss warehouse

For a story on perfume, I needed to show the scale of this warehouse full of bales of moss, an ingredient used by the French distillery. Alone they made an unintelligible mass, but with an added lab technician they made visual sense. The figure is off-center as the real subject is the moss.

An eye for the unusual

Even allowing for the inevitable differences in customs, traditions, and societies, certain people in certain situations stand out. They deserve to be treated with an informed and affectionate eye.

The element of surprise plays a constant part in photography, probably more so than in other visual arts. Fundamentally this is because almost all photography is a record of actual life rather than invention, and in order not to be repetitive photographers look for something new in what they shoot or in how they shoot. The unexpected, the fresh, and the unusual have become underlying expectations.

This applies to people and portraits every bit as much as to other camera subjects, although as you might imagine there are some limits and protocols to be observed. Unusual can cover a wide range of interpretation, not all of it pleasant or tasteful. Just as with general differences between cultures, it's a matter of judgement as to what constitutes unusual appearance or behavior. And here, at least, we're playing safe and focussing on the very obviously odd, while at the same time looking at the humorous rather than the unpleasant side of life (although culinarily challenged readers may disagree in the case of the Khmer girl photographed here).

Much of this is down to personal judgement, and you can be sure that whenever you search out and photograph the peculiar, there will always be a number of people who do not appreciate it as much as you. Still, for some of us the odd moments in life are a treat, and if you have at least a slight sense of the ridiculous, keep your eyes open. If a situation strikes you as quirky, then shoot it. That said, it is precisely the unusual nature of situations such as those shown here that makes them rare. In general, they have to be sought out and, to some extent, organized. These examples were all researched beforehand, and the portraits were posed for their strongest effect.

 A brisk dip
Scandinavians acknowledge the invigorating effects of a sauna followed by cold water, but here in Lapland they take it even farther. An impromptu swimming pool has been carved out of the thick ice covering a river. This seemed the moment to shoot—when there was no turning back.

Ratcatcher
The Irula, a tribal group near Madras in southern India, have become specialists at catching the rats that live beneath the rice fields and consume a third of the country's rice crop. Under a sponsored program, they are paid for the catch, some of which is sold to local snake farms.

A chilly breakfast
Close to the cold bath at left, a hotel has been constructed from ice. After a cosy night spent sleeping on a block of ice (admittedly in a sleeping bag), guests can have breakfast served in their rooms, where the temperature is a balmy 5° Celsius.

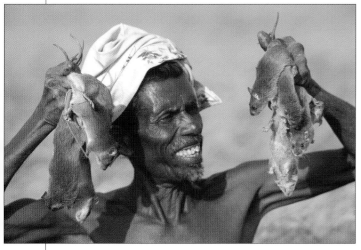

Arac snack
A culinary speciality of one small town in Cambodia is deep-fried tarantula, sold at the side of the road to passing motorists. Reminiscent of soft-shell crab without the fishy flavor, it remains a local delicacy with poor export potential. One of the stall-holders was only too happy to bite into one of these arachnids for a photograph.

Intimate moments

Discreet observation with the camera will, every so often, give you the chance to capture the candid occasions when people are absorbed in their own thoughts or in each other.

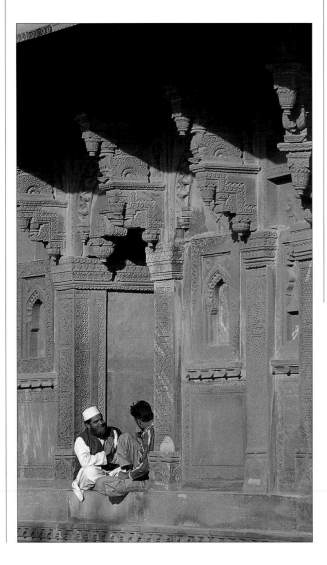

The line between a posed portrait and a candid shot is, perhaps surprisingly, a fine one. Put another way, what actually is a candid photograph? We normally use the term to refer, often vaguely, to images of people taken when they are unaware, and it carries overtones of a hidden, surreptitious camera. This can indeed be the case, but by no means necessarily.

The question is highly relevant when it comes to images of people so completely caught up in their own world that they are oblivious to the photographer's presence. They may be in a reflective mood, engaged in private thoughts, or quite commonly they may be two people deep in conversation. There's a special value to photographs of this type of moment, because such images usually have more character, are more intense in feeling, and are more charged. The viewer has the sense of being privy to a kind of intimacy, and is more likely to be drawn into the picture than when the expressions are blank or uninvolved.

These moments are also more difficult to shoot, partly because they are less common and partly because they require the subjects to be completely unconcerned

◀ Fatehpur Sikri

Seated on the sill of a window in the abandoned sixteenth-century Indian city of Fatehpur Sikri, two men were deep in conversation. The red sandstone monuments, though architecturally magnificent, are normally lifeless apart from strolling tourists, and natural human activity like this made a welcome change.

▶ Taj Mahal

An Indian couple in an alcove of the Taj Mahal (hence the bare feet, as all visitors must remove their shoes), more interested in each other than in the monument. As in the picture opposite, natural moments are less common at such heavily-visited sites, so all the more valuable for photography.

about the presence of a camera. So, even if you have
set up the occasion and the surroundings for a portrait,
you'll still need to give your subject the opportunity, the
space, and the time to relax and forget about you. This is
a good case for stepping back and being, if not actually
out of sight, at least out of your subject's field of view.
This kind of image is usually best taken with a telephoto
lens from some distance away. If you are close, the
camera will be a distraction, particularly if you are
continually raising it to your eye every time you think
the person's expression is about to become interesting.

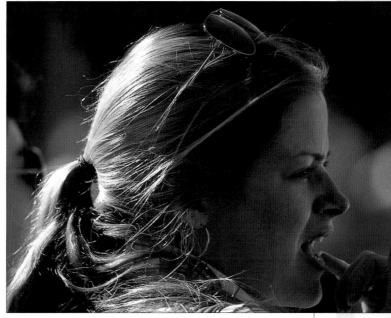

Reflection
Sunlight glints off
the hair of a girl lost
momentarily in her
own thoughts.

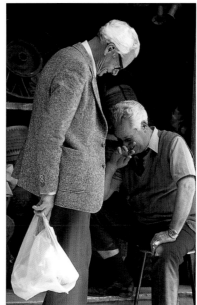

A private joke
Two men in an Athens street, one of them just
returning from shopping, share a private moment
of amusement.

City scenes

These are the great energetic concentrations of human life—open season for the camera and offering the strange combination of connectedness and anonymity.

There is no shortage of potential portraits in a city, and whether this is where you live or an unfamiliar one abroad, it will contain a wealth of opportunity. This extends beyond people as subjects for the camera to settings and backdrops; there is no shortage of locations for posed portraits, particularly among downtown public spaces.

Cities naturally have a specific character, most obviously in the prominent buildings and public spaces (the immediate mental image of Rome, say, or Paris or Sydney, tends to focus on the central, somewhat clichéd views of the Spanish Steps, Eiffel Tower, Opera House), but

◀ **Rush hour**
London Bridge as commuters stream across from the railway station headed for the financial district. Planning and viewpoint are the keys to shots like this.

▶ **Park bench**
Parks in the center of cities offer another take on urban life. Two residents of Athens relax in the afternoon.

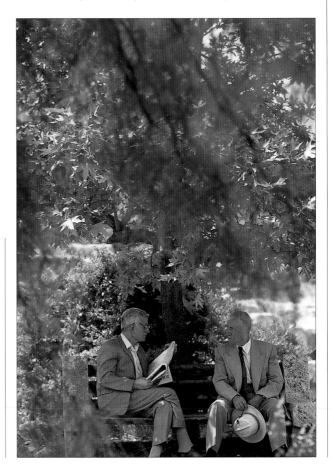

Location checklist

☐ Downtown shopping areas, pedestrian precincts.
☐ Downtown entertainment district.
☐ Business district.
☐ Parks and recreation areas.
☐ Bridges.
☐ Stations, especially at rush-hour.
☐ Sidewalk cafés.
☐ Traditional areas: "village in the city."
☐ Markets (wet markets, produce, farmers' markets, antique and flea markets at weekends)
☐ Squares and plazas.
☐ Events, processions, parades.

also in the style of daily life. If you want to reflect the character of a city through its people, spend time observing the street life and note the differences in dress, behavior, and custom.

The key to city shooting is research–of location and time (*see boxes*). Use a guide book and street map to check locations, and work out when the action is in each. Despite local and national differences, city life worldwide tends to converge. Specific activities such as business, shopping, and entertainment cluster into certain parts of town. Rush hours are common to all, though the timing differs (early in the morning for Tokyo, late for Madrid), and certain spots are predictably crowded: London Bridge, Grand Central Station, Hong Kong's Star Ferry.

There is an anonymity in all this to-ing and fro-ing, and you can take advantage of this in shooting–photographers do not stand out in busy city centers as they would elsewhere. Using a camera is seen as a completely unremarkable activity.

Dance class
A strange but oddly charming sight for foreigners is the dancing class held early in the morning on Shanghai's Bund, or waterfront, with its elegant Art Deco backdrop of buildings. Idiosyncrasies like this help to give character to city photography, and in this particular case the opportunity to combine people and cityscape in one shot.

Work, rest, play

☐ **Work** Morning and evening rush-hours, lunch-hour, workplaces.
☐ **Rest** Diners, restaurants.
☐ **Play** Bars, entertainment districts, family amusement parks.

Small-town life

Less dynamic and less crowded than cities, provincial small towns are a setting for people who generally have a stronger sense of community.

Compared to cities, small towns have a stability and regularity that translates into a slower pace of life, fewer complete strangers, and a better connectedness among people. Older towns also tend to retain something of their original character, at least in the centers.

Here anonymity does not work as well as in cities, and as a photographer you don't naturally recede into the street life. Equally, it is generally easier to make connections with people, to introduce yourself and have conversations. The places where people gather are fewer than in large urban centers, but easier to reach, and there is usually just one hub.

Traditionally, most towns evolved as places where transport routes crossed and as trading centers for the surrounding countryside. Many still function as market towns, and it's worth checking the dates for market—often weekly. It's also because towns serve a particular area that they often develop a specific character. The local economy tends to dominate, and you can see aspects of this reflected in the way people live—mining towns, seaside resorts, small ports with a fishing fleet, spa towns, mountain ski resorts, and so on. If you look at what makes a town special, you can use this to add a distinctive character to pictures of its inhabitants.

▲ **Village green**

Cricket, a quintessential part of English village life, is at its most picturesque played on a small green. A telephoto lens made it possible to include three players in the same frame.

▶ **Sunday morning**

The end of the service at an attractive church in a small Ontario town—one of the few occasions in the week when more than a few people gather together in public spaces.

▲ Peruvian café

In a mountain town in the Andes, one of the regular clientele of a café plays an old harp, as much for his own amusement as for the entertainment of other people.

▶ The publican

The owner of 't Brugs Beertje, a Belgian bar, pours one of the four hundred brands that he proudly stocks.

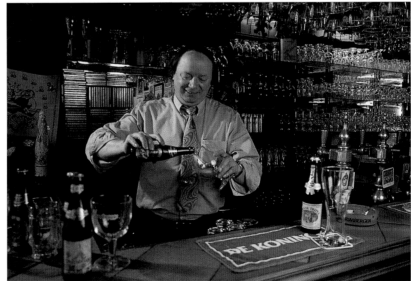

Rural communities

Fewer people, but more tradition, characterize close-knit societies with lives that are obviously connected to the land or the sea.

For life at its most traditional, look for farming communities. How traditional, indeed how fully occupied, these agricultural areas are depends very much on how developed the society is generally. The biggest changes have been in the West. In a country like England, for example, the most attractive and apparently traditional hamlets and villages are actually in a state of preservation, with many of the inhabitants likely to be commuters who work in nearby large towns, or city dwellers for whom the cottage is a weekend retreat. Pretty though these settlements may be as places, they are often disappointingly arid in terms of people.

With this exception, rural communities offer a particular kind of opportunity for photographing people, quite opposite from city life. There is not the same concentration, no crowds, no rush hour, and this means initially harder work for the photographer in meeting people, making introductions, and explaining what you do and why you want to take photographs. Once this

▶ **Burmese cheroot**

Wearing a broad conical hat typical of the area, a market trader north of Mandalay smokes one of the cheroots made famous in Kipling's poem *Mandalay*: "... An' I seed her first a-smokin" a whackin' white cheroot." Backlighting from the morning sun catches the tobacco smoke.

is done, however, shooting often comes more easily than in cities. Two of the most exceptional qualities of rural life are that everyone knows everyone else, and that most are in some way connected to the land. Once you have made yourself known to a few people, they can introduce you to others, and there is no shortage of activity. Working the land is a full-time occupation, and physical, so much easier to photograph than deskwork.

Where people concentrate

- ☐ **The store** General store, village store, post office.
- ☐ **Place of worship** Church, mosque, temple, shrine, field shrine.
- ☐ **Café and inn** Tea-rooms, café, pub, inn, diner, coffee stall.
- ☐ **Market** Weekly or daily (sometimes even rotating from village to village).

Seasons

Agricultural life is tied to season, time of day, and other cycles of nature. It helps to know in advance what the pattern of farming or stock-raising or fishing is. Activity concentrates in the following-
- ☐ planting
- ☐ preplanting
- ☐ harvesting
- ☐ tides
- ☐ pasture
- ☐ post-harvest events
- ☐ preparations for winter.

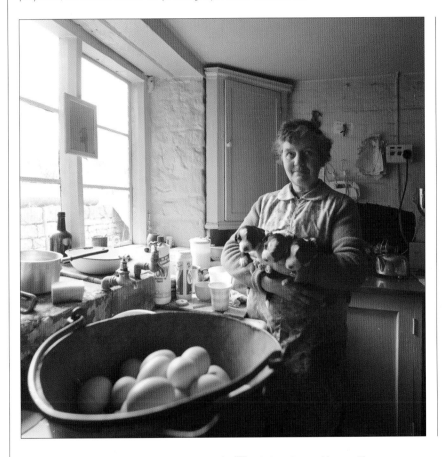

▲ A farmer's wife
A pail of freshly collected eggs on the kitchen worktop and a trio of new puppies from the farm's sheepdog start the day for a Welsh farmer's wife.

▶ Water from the well
On the edge of the Thar desert in India's Rajasthan, water has to be drawn daily from wells situated close to the villages, a task performed by women, usually late in the afternoon.

Minority cultures

Smaller, isolated societies, decreasing in number around the world, make intriguing opportunities for portraiture, but need to be approached with both tact and patience.

All societies are different, but some are more different than others. What counts as normal and what as exotic depends mainly on the person thinking about it, and in our case the person taking the photographs. Which is why it's as well to be careful about shooting unfamiliar societies as if they are odd. To them, you may be odd.

Nevertheless, photography helps to satisfy our innate curiosity about how other people live. Minority cultures, most of them tribal, tend by definition to follow lifestyles that are distinctly different from anywhere else. The people may look and dress differently, which is something that the camera can easily deal with, although in the last few decades traditional dress around the world has quite rapidly disappeared except during ceremonies.

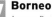 **Borneo**
A young Dyak girl from Sarawak looks curiously at the photographer while she shields her face with the hat she has been using for protection against the sun.

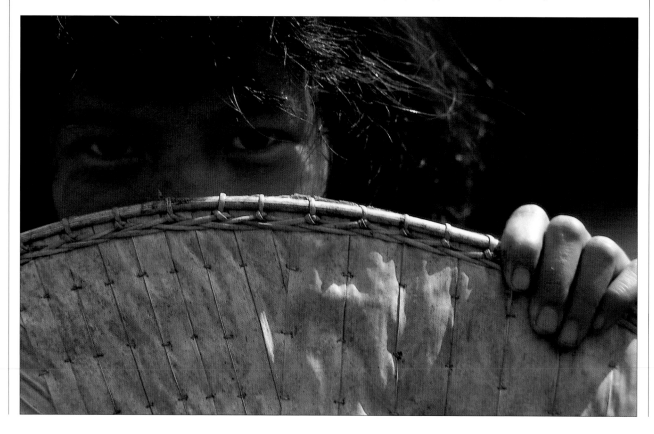

Most minority cultures are relatively isolated and even clannish to some degree, either by choice or circumstance, and this does inhibit photography whether you like it or not. Tourism either reinforces this, so that some tribal societies such as the Hopi in the south-western United States simply ban photography, or it commercializes it, so that you can take photographs but in fixed situations for which you will have to pay.

Taking portraits in relaxed, genuine, everyday circumstances nearly always demands a commitment of time and effort. You will usually need a guide and translator, have to go farther than the tour groups, and spend time in the community—the more, the better. This may well not be worth it if all that you need are a few good portraits. This kind of almost anthropological photography is not, frankly, for everyone. The commercialized setups at tourist spots are certainly not a satisfying experience, but if you simply want a close portrait of someone in tribal costume, it may be better to do it this way. If so, at least try to engage your subject in a worthwhile conversation and exercise some charm in order to get a kind of realistic expression.

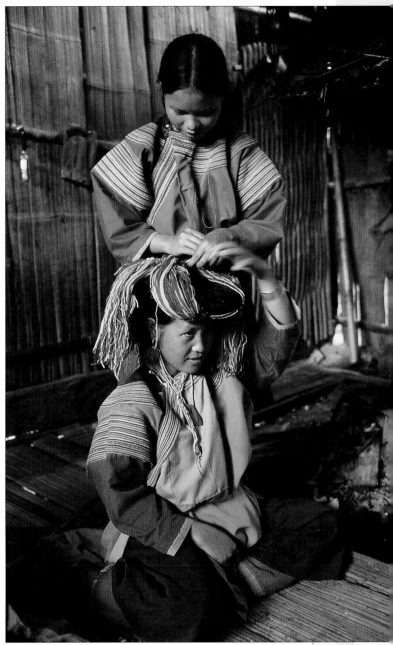

A Pathan tradition
On the Afghan-Pakistan border, a Pathan man instructs a young relative in the essential skill of how to use a rifle. Fiercely protective of their customs and their independence, Pathan men generally carry arms as a matter of course.

Lisu girls
At a Lisu hill-tribe village in northwestern Thailand, a girl prepares for a wedding ceremony, helped by her friend as she dons a traditional costume of bright silks and silver.

Following one subject

Instead of settling for a single image in one chosen situation, consider following your subject during a round of activities—with the intention of displaying a grouping of several images.

In most portraits, the photographer is looking for a single "best" shot, and many of the techniques and strategies that we've looked at so far have been directed at finding this. Yet another approach is to build a composite picture of a person by photographing them in a variety of situations and activities. Clearly, this kind of extended portrait works best with real-life photography rather than strictly posed settings, because much of the success depends on showing your subject interact with events—in other words, building a story.

This is mainstream reportage photography, and may have as much to do with the person's activity as with their appearance. We will return to this area at the end of the book when we look at picture essays, but for the time being we want to see how a series of portraits can work when they are displayed together, side by side.

The keywords are variety and coherence. These two slightly contrasting qualities have to work together, and in principle the variety should be visual while the element that ties the images together is the storyline. Just having several individual portraits of one person, however varied they are in scale,

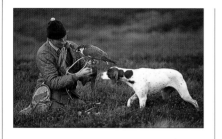

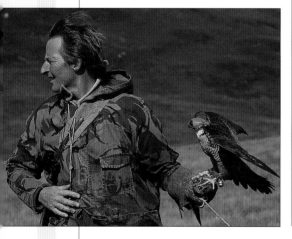

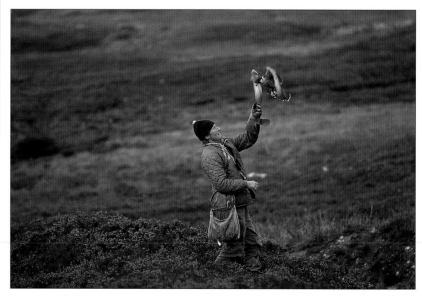

Preparation
The bird, a Peregrine falcon, is kept hooded until it is ready to fly. The falconer adjusts the thongs attached to the bird's legs, as his dog, a pointer, sniffs his gloved hand, bloodied from an earlier kill. The role of the pointer is to find the grouse, keep them pinned down until the falcon is up, and then dash forward to put them up into the air.

lighting, expression, or whatever, is unlikely to tell us anything new. What is needed is a sequence and relationship with what the subject is doing. One easy device is a day in the person's life (*see the case study following*), another is a project they are undertaking. The examples here are from editorial magazine assignments on subjects more wide-ranging than the people by themselves, but they still show a more rounded view of the people than would a single portrait image.

The kill

As the prey breaks cover, the falcon swoops and strikes it in midair. By the time the falconer arrives at the scene, it has already started to eat.

Patrolling for grouse

Launched and ready to swoop, the falcon scans the ground for signs of grouse, as the dog attempts to flush them from the heather.

The return

On some occasions, the falcon has to be tempted back with a bait of meat that the falconer swings around on a line. It's important to keep the bird hungry while out on the moors, or it may simply fly off and perch on a crag for a day or two. Finally recovered, bird and man walk slowly home.

Case study: **A day in the life**

Dr Ating, a doctor and parasitologist on contract to a U.S. Navy medical research unit, is stationed in the Baliem valley in the Central Highlands of Irian Jaya, where he is researching the incidence of malaria that is creeping up from the lowlands. His subjects and patients are from the surrounding Dani tribes, most living in remote settlements.

Blood tests
The larvae search is followed by testing a cross-section of the population for malaria parasites. Dr Ating's two assistants, research students from Jakarta, escort the patients—40 of them on this day—and log the data.

Arrival
Ating's arrival by helicopter at the mountain village of Amuma is an event. Although only 20 minutes' flight from the main town of Wamena, it is a grueling four-day walk, and the villagers see very few visitors to this high valley. Almost the entire community turns out to greet him and escort him down to the settlement.

Dipping for larvae
The first part of the day is spent dipping for mosquito larvae from ponds scattered around the hillside, to check the species. He takes time to show some boys from the village how to identify the tiny creatures. Despite the altitude and chilly nights, boys and men traditionally dress in nothing but a sheath made from a gourd.

Events and Occasions

The distinction between special and ordinary is hazy, in human activity as elsewhere. It depends as much on the person seeing and the interpretation put on a moment or an event as it does on its inherent nature. To this extent, the division in this book between daily life and events is a little arbitrary. Indeed, between these two and posed portraits there are many overlapping situations. The common denominator in all of this is people, in all their many changeable states.

Nevertheless, from the practical point of view of photography, picture-taking tends to follow somewhat different rules and principles at times when people set out to do special things. Events and occasions, as I've called it here, is something of a catch-all expression, and includes, among other things, parades, processions, festivals, public appearances of famous people, artistic performances, sporting fixtures, weddings and the other rites of passage, celebrations, wakes, and more. What they tend to have in common is that they are planned, organized, aimed at presentation in one form or another, and that the participants are prepared to go to some effort to make the whole thing work.

For photography, this makes life both easier and more difficult. On the plus side, the focus of an occasion, and the fact that it is usually designed for an audience of some kind, makes it likely that there are visually worthwhile subjects. There is also the bonus that people attending will probably be more animated or at least expressive, and a good chance that there will be a celebratory component, with people in a good mood.

Against this for the photographer is the matter of access and permission. Organization is wonderful when it works—and works in your favor—but if you are on the receiving end of restrictions that make it difficult to shoot, the occasion can simply be frustrating. There are ways of avoiding this, involving planning, creative problem-solving, and a reasonable, affable manner in dealing with event organizers. The more formal the occasion, the more time you should devote to preparing for it, making contact with the people running it, and finding out what you can and cannot do. What you want as a photographer may well turn out to be achievable without breaking the rules and upsetting the procedures. Discovering whom to ask is a basic skill.

And what does this have to do with portraiture? Very little if your idea of a portrait is a perfectly lit face filling the frame. But, as I hope I've already demonstrated, photography has helped to redefine the portrait through its ability to show how people are and what they do in a wide variety of circumstances. If heightened excitement, emotion, or interest at a special event brings out extra layers of behavior, then these are valuable occasions for photography. And as occasions, they will nearly always yield a number of shots of different kinds. There are overall shots, both the immersive, wide-angle kind and the compressing telephoto type. There is the key moment, or several. There are the asides—spectators' faces, unpredictable occurrences, behind-the-scenes activity. Much depends on the nature of the event, but none of them are one-shot deals. Expect to shoot a lot.

Parties and gatherings

Whether you are the "official" photographer or just another guest with a camera, parties present a rich vein of opportunity for shooting people.

Knowing what you want to achieve before you set out is one of the most important steps in creating a good set of images. Nevertheless, every party and gathering has a life of its own, so as photographers we need to be flexible when we turn up with a camera. Planning for the unexpected might seem like a real contradiction but it's the best way to handle this particular type of photography. Make sure that you know what the location is like so that you have some idea how you are going to handle the light. If the existing lighting is reasonably even and relatively bright (for an interior), consider racking up the ISO sensitivity and shooting without flash. Alternatively, use fill-in, rear-curtain sync, flash as described on pages 42–43.

There are essentially two ways to approach parties and gatherings. You can decide to shoot as a "fly on the wall" and be an observer or you can shoot pictures with the full cooperation of the other guests. The type of the occasion might dictate which approach you use because some more formal gatherings have their own protocols. Children's parties will inevitably be a lot less formal and give you more scope for a good combination of posed and candid shots. The important thing to remember is that a photographer should always take their lead from the host of the party.

▲ Pathan feast
The slaughter of a water buffalo is the occasion for a feast at a Momand Pathan village in Pakistan's Northwest Frontier province, to which old friends and relatives have been invited—a chance to catch up on events, and for the photographer to catch a variety of expressions.

▶ Relaxed moments
Parties are occasions for people to relax, chat, and joke, at which time they normally pay no attention whatsoever to someone with a camera, particularly if you shoot from a slight distance. There are endless opportunities for photography with a medium telephoto.

▲ **Summer cottage**

At a lakeside weekend retreat near Ottawa, the children entertain themselves by licking a honeycomb while their grandmother looks on.

▲ **Mad Hatter's tea party**

This was a party with an *Alice in Wonderland* theme, organized by the local municipal authority, with organizers dressed for the part. A wide-angle lens used close into the crowd gives a sense of being in the thick of things—typical of what is sometimes called "subjective camera."

Seven tips for shooting parties

- ☐ If it's a large gathering and you are taking candid photographs, try using a telephoto lens and shooting from a vantage point slightly above the crowd to pick out individuals.
- ☐ If you decide to set up some lights, make sure that any power leads or sync leads that you use cannot be tripped over or have drinks spilled on them. Run them under carpets and tape them down securely.
- ☐ If you are shooting while circulating, try to keep your equipment down to an easily managed level. There is nothing worse than bumping into people with cameras all of the time.
- ☐ If people are eating or drinking, try not to shoot when they have their mouth open or have a glass to their lips unless you know them very well and know that they wouldn't mind.
- ☐ If the party has a guest of honor, make sure that they feature in more than one picture and that they are photographed with the host.
- ☐ If you don't know everybody there, ask one of the organizers to point out some of the key people.
- ☐ If you are there as a guest rather than as a photographer, remember to enjoy yourself!

Weddings and anniversaries

There is a big difference between being a wedding photographer and being a photographer at a wedding. Shooting weddings is a professional skill that takes years to master, but taking your camera to a friend's wedding is a different matter.

A lot of people with a camera at a wedding find themselves standing next to the official photographer snapping the group photos that they carefully arrange. This is a tempting idea, but it's not much fun for those of you who like a creative challenge. Professional wedding photographers often act as the master of ceremonies and have their own schedule to fulfill, but there is another type of photograph that you can take, a far less formal and more intimate kind of picture. These will remind everyone of the special day just as warmly as the formal and posed ones. A photographer who is free from the need to organize everyone can move around and shoot relaxed candid images in those unguarded moments while the guests and the wedding party socialize.

Different cultures observe very different rituals leading up to the wedding, so even before the big day there are some great wedding images that can be captured. Many cultures have occasions similar to the American bridal shower where the bride's close female family and friends will gather to give the bride gifts and enjoy some time without the men. Other cultures have parties for the groom and his friends, where the last days of

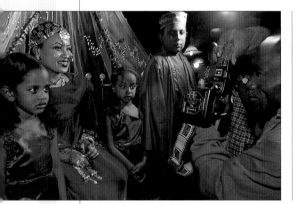

▲ **Wedding photos**
At this Muslim wedding, the official photographer becomes part of the shot as he records the bride on the evening at which only women attend. A mix of existing lighting and fill-in flash provided the illumination, using the Auto white balance.

▶ **Posing**
Take advantage of the distraction afforded by the demands of the official photographer to catch subjects off-guard.

bachelorhood are enjoyed. These are just two examples from all sorts of prewedding events that can make memorable and valuable pictures.

On the day itself, the last-minute preparations and the time spent waiting can be interesting, although these moments should be shot only with the permission of the families. As the day progresses, you can build up a narrative of the proceedings that tell the story as well as any video.

Anniversaries

Most people hope for only one wedding and many anniversaries. Celebrating a wedding anniversary is always a happy occasion and can make great photographs. The nature of the celebration is different around the world, but the scope for memorable photographs isn't. Hiring an official photographer for an anniversary celebration isn't as common as it is for the wedding itself, so a friend or family member is often called into action to capture the day. Everything about anniversaries is less formal, so an informal set of pictures will be in keeping with the occasion.

Referring to the best photographs of the wedding itself is often a great starting point when planning what to shoot. Recreating group photos five, ten, or twenty years on can be a good idea as long as most of the people in the original picture can be there. Shooting a husband-and-wife portrait to give to guests at the anniversary party can also be a good gesture.

Share the shooting

Photographs shot digitally are easy to share on the camera's LCD screen. Many cameras have the facility to be connected to a television monitor, and if there is a break in the day it might be worth sharing the pictures on a decent sized screen too.

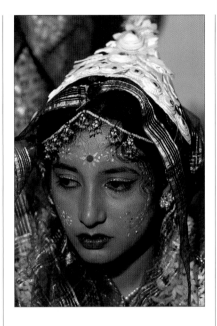

Bride, Calcutta
Dress figures prominently in most weddings. The bride at a Hindu ceremony wore a spectacular and colorful sari, as well as traditional makeup. The richness of color responded well to direct flash, not normally the lighting of choice for portraits.

Successful wedding shots

Hundreds of photos will be taken at a wedding, but many will be dull variations on a few obvious themes. Take a different approach:

☐ **Background detail** By keeping the focus on the bride and groom or the formal parts of the day, you can miss interesting family moments taking place in the background. Watch out for them and be ready to act promptly.

☐ **Waiting** There is a lot of dead time during any wedding. Use it to catch the less important participants in informal shots.

☐ **Plan** Have some idea of the shots you want to take and when you want to take them, but keep this flexible.

☐ **People** Knowing the people involved helps you to capture their mood or character during the different stages of the day.

As with any formal occasion, use discretion while you shoot. Keep the feelings of the family in mind and avoid being intrusive.

Rites of passage

As well as weddings, other milestones in life are celebrated, or mourned, according to the culture and religion. Most are good situations to photograph, and the results will make a record that is appreciated by the people involved.

Weddings are perhaps the most popular of family special occasions for photography, but there are a number of other events in life that call for celebration or, when less happy, solemnizing. In most cases the camera has a role to play, because not only are these rich opportunities for taking photographs, but the people you photograph will welcome pictures for themselves. Births, coming of age, even funerals are rites to be observed and marked—and photography does this well.

Ceremonies such as these have a social importance, and so tend to be more numerous and fuller in traditional societies. As a rule, the more rural and less industrialized the culture, the more varied they tend to be. If you travel, keep your antennae tuned for them, because at these occasions you are likely to find interesting and concentrated collections of faces and activity. Ask around and you may be surprised that, even as a stranger, you will usually be welcomed.

Getting permission is, of course, the first essential, and not just from the individuals involved. The ceremony may be held elsewhere than at their home, particularly if there is a religious aspect to it, as is often the case. For similar reasons, there may also be other people officiating, such as a priest or a monk, and you should make sure that they have no objections either. Ask also about restrictions; in a place of worship such as a church there are likely to be areas which you cannot enter, and it's as well to know about these beforehand. Also in tune with not disturbing the events, ask before you use flash. Better still, given the ability of digital cameras to adjust sensitivity and work well at moderately low interior light levels, consider using a high ISO setting and shoot as much as possible by available light.

As with any organized occasion, arrive early if you can and find out the sequence of events and a rough description of what will happen. This applies even more if you are in a foreign culture, as there are likely to be unfamiliar aspects to the ceremony. If there is a local professional photographer, he or she will know what is about to happen at any given point. If there is a video cameraman, the likelihood is there will be a 3200K tungsten light in use some of the time—a good reason for leaving your white balance setting on Auto.

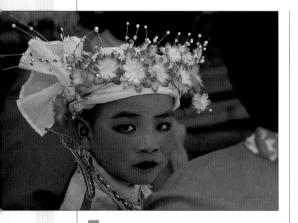

▲ **Shan ordination**
A major ceremony in the life of Shan males in northeastern Burma and northwestern Thailand is *shin pyu*, the ordination into the Buddhist monkhood. In reference to the Buddha's original princely life, which he rejected, ordinants like this young boy dress before the ceremony in an ornate costume and wear makeup.

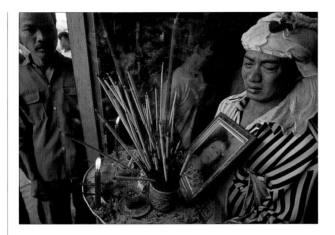

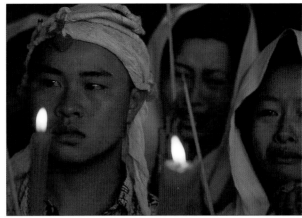

Vietnamese funeral

Funerals are almost always difficult occasions for photography because of the grief involved. It is absolutely essential to arrange permission first, and it may be more appropriate to do this through a friend of the family or someone officiating rather than directly.

Grief and respect

It can be difficult to achieve a balance between capturing the emotions and atmosphere of the rites, without disturbing the understandably tender feelings of the mourners. On the other hand, many people welcome the record and respect that photographs can offer.

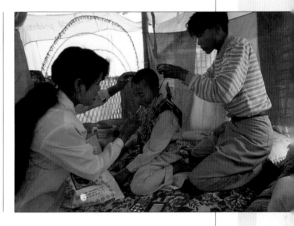

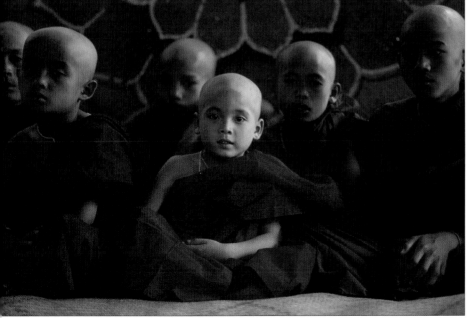

Monks

In a continuation of the *shin pyu* ceremony opposite, the young boys' heads are shaved, after which they exchange their fancy costumes for the red robes of a monk.

Preparation

Most of the boys will spend just a few weeks during the rainy season—the Buddhist Lent—studying in a monastery before returning to normal, family life.

People and religion

A major component of many people's lives, religious belief inspires a rich variety of activities that can be wonderful for photography—provided that you know exactly what is permissible.

As we see daily, religion inspires considerable depth of feeling and emotion, as well as entering the structure of many people's lives. If we look at the positive aspects of religion rather than the conflict that also occurs because of it, we can see an aspect of life that makes a fascinating challenge for photography. Faith and belief can affect people profoundly, and capturing this on camera adds an extra dimension to your portraiture.

Whether or not you are religious yourself, you should be prepared before you aim to photograph its activities, such as worship, prayers, blessings, and various rites. This is not only for practical reasons, so that you know what to expect in terms of images, but also because all religions have particular observances. There are almost always limits to photography: in what you can shoot, where you can shoot from, how you should dress and behave, and whether, in fact, as a nonbeliever in a particular faith you can even attend. This makes it essential to research in advance and then, as always, to ask permission from the appropriate people. Some religions have segregated worship and dress codes, so your gender will make a difference. There is, needless to say, little point in trying to argue against restrictions which may prevent you from taking a particular photograph that you had in mind.

◢ Wailing Wall
In the old city of Jerusalem, the sheer 58 foot Wailing Wall, or Western Wall as it is also called, is the remaining substructure of King Herod's temple, and now a focus of solitary prayer for devout Jews. The mediation of a rabbi is not necessary at such a holy site.

▼ 2000th birthday mass

A large open-air mass in Luneta Park, Manila, to celebrate the 2000th birthday of the Virgin Mary. Here, the large painting of the Virgin was a strong, obvious addition, and placing it to the right helped connect the scene, as the face looks down toward the cardinal giving a sermon.

▲ Thai temple

A boy lights a candle as an offering at a northern Thai temple—a common enough happening, but in this case the lighting made the shot worth while, with a narrow shaft of sunlight striking the profile of his face.

▶ Ceremony

The rituals of the Greek and Russian Orthodox churches use the same tones of gold and copper that remain so prevalent in the church architecture. Capturing this in low-light conditions is a challenge, but one worth rising to.

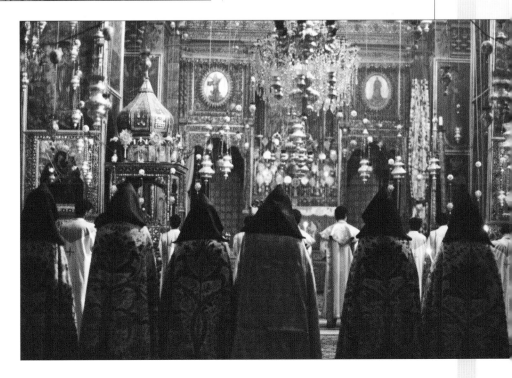

Parades

Parades, fairs, and other public showcase events offer some of the richest and most colorful possibilities for photography. Finding the right viewpoint for the right moment is essential, and the key to this is planning.

There is never any shortage of material for photography in organized events such as these, and the only serious concern is usually working your way around the crowds. Most events are highly structured, and you can usually expect to find viewpoints and work out the timing in advance, although you can expect some restrictions.

If you have enough time in the days before the event, get a schedule from the organizers or the local newspaper. Then look around the site or the route to find the best vantage points. If the event is very popular and likely to be covered by the media, the very best positions are likely to be reserved, but even then doing your own groundwork can turn up a free viewpoint. Also, there is no harm in asking if you can enter the area or seating set aside for the press—even if you have no professional claims to a press pass, there is always a chance if the occasion is relaxed.

Somewhere high, like a balcony or the roof of a building, is often a good, safe bet, offering you a variety of images with different lenses. Even a slightly elevated position is useful for shooting over the heads of crowds—if you are checking before the day, anticipate where other people will be. The disadvantage is likely to be that, on the day, everywhere may be so crowded that you can't move. All of this, of course, depends on how big and busy the event is. If you know that you will have to stay in one fixed position, take more rather than less equipment—a tripod, for instance, is useful with long lenses (just loosen the head when you use it so that you can pan around the scene). On the other hand, if you are going to be on the move, take only what will fit easily into one bag. Take more memory cards than you think you will need—these occasions encourage heavy shooting—and if possible carry two camera bodies so that there is no risk of losing a shot at a key moment.

Most events, in fact, turn around one or two key moments, such as the high point of a procession. Always try and make sure that you get these, but don't ignore all the other possibilities that may occur. These include the asides, the unpredictable events, behind-the-scenes preparations, and the faces and reactions of spectators.

▲ **Carnival #1**
A medium telephoto lens fills the frame with the color and energy of Kingston's annual carnival in Jamaica. Dancers and bands move in sections separated by gaps, giving the opportunity to shoot from in front.

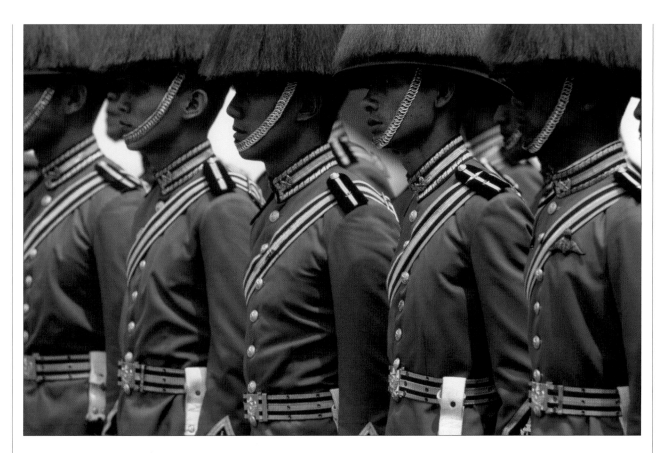

◀ Carnival #2

A brightly costumed and helmeted dancer at the Jamaican Carnival gets ready to move off, just before the beginning of the parade. As well as the obvious scenes during a procession, there are many opportunities for detailed portraits, for which a medium or even long telephoto lens is useful.

▲ Military order

The regularly ordered line of these Thai soldiers, photographed obliquely with a long telephoto (400mm efl), provides the setting for a rhythm that begins when the eye scans the image, moving from faces to the lines of the uniform and back again.

Tip

Some professional photographers who are used to covering special events, carry a short, lightweight stepladder to guarantee a clear view over crowds.

Behind the scenes

With easier access, fewer restrictions, and the chance to see things that may be hidden from the normal audience, rehearsals and preparations offer great opportunities—sometimes better than the event itself.

While it's normally assumed that a procession, parade, festival, or performance is bound to be the focus of interest for everyone, it may not necessarily deliver the best photographs. This entirely depends on the interests of the photographer, but the sheer weight of organization that goes into many events can also make the imagery predictable—and shared by all photographers present. Going behind the scenes can give you the opportunity to be more original and see things from the more workmanlike point of view of the participants. Also potentially interesting is the reaction of spectators watching an event. If the occasion is sufficiently riveting, their expressions may make a better subject for the camera than the object of their attention.

Vietnamese opera

This was a traveling opera troupe that had set up stage in a provincial town in southern Vietnam. The conditions were far from comfortable, with make-up and costume taking place in the cramped space underneath the stage itself. The lighting was minimal—a few lamps and candles—but the scene was strong on atmosphere.

Corpus Christi

This strange, almost unintelligible scene was a rehearsal for an event that was already a little peculiar—Corpus Christi day in a small Venezuelan town, where the action revolved around masked and red-clad so-called Devil Dancers. The main event also delivered many good images, but this individual rehearsal of one dancer and a drummer in an oddly painted room was my favorite.

Coach rehearsal

The streets of London on a wet early morning in November presented a very different aspect on the day before the Lord Mayor's Show illustrated on page 107. Before commuters and traffic filled the streets, the coach, wrapped in plastic, was driven around the exact route for familiarization. As it stopped on a pedestrian crossing, the only spectators, slightly bemused, were a group of office cleaning ladies.

Sports events

When you think of sports, you think of action, the World Cup, the World Series, or the Super Bowl, but many of the best sporting images ignore the action altogether and feature portraits of fans, hot-dog vendors, and souvenir sellers.

The sad fact about trying to shoot professional sport these days is that, unless you are an accredited member of the press, it is very difficult to get access to the venues with your camera. All of the governing bodies and the top clubs now try to manage their image and that includes trying to prevent unauthorized photographs from being taken of their valuable stars. Lower league and amateur sports, on the other hand, present an almost endless supply of photographic opportunities, which you can use either to enjoy your photography or as practice for when you become good enough to move up to the professional ranks.

Depending on your interests, the world of sport offers you nearly every type of "people-centered" photograph that you could imagine. Whichever sport you choose, photographing it has its own challenges and conventions, but there are some basic principles that you can follow with all of them. The atmosphere at even the smallest sporting event is worth capturing. Freezing parents on the touchline at a children's soccer match and anxious little-league coaches behind the nets at a softball game are perfect subjects for candid, long-lens pictures. Early morning golfers as they set out on their round and mud-covered mountain bikers fresh from the race make great portraits. It pays to be familiar with the rules and etiquette of the sport

Midair
Even the most basic amateur sports can offer some worthy photo opportunities. In this shot by Martin Gisbourne, quick thinking captures the action in midair.

Speed
This rider in the Tour de France would have passed the camera at about 35mph. With a shutter speed of 1/2500 second, the photographer froze him in the moment.

concerned before you start shooting, so that you know what's going on and so that you don't go anywhere you shouldn't.

Planning your sports shoot usually starts with finding out when and where the event is taking place. It is good manners to contact the organizers to make sure that they are happy for you to be there with a camera and to find out what restrictions, if any, they place on photography at their events. The equipment that you choose to take with you will dictate how close to any action you can get, and it's worth noting that a large number of sports don't allow the use of flash photography because it can be distracting to the competitors. For most sports, you really need a fast and long telephoto lens to get close to the action. It's normally a good idea to get as close to what's happening as you can, and if you have zoom lenses you can frame your shots without having to move around too much.

Getting great sports photos requires more practice than almost any other style of photography. Time spent at the local stadium will never be wasted because learning to anticipate what is going to happen next is a key skill for sports photographers. Starting out with amateur or school sports is wonderful training because it is often harder to predict the next move in the lower leagues than it is in the professional ranks.

▶ Using blur for effect

Sometimes a moderate shutter speed will capture certain fast moving parts of a photo with some blur, retaining sharpness in the more static areas. In the top shot, the San Jose Sharks' Jonathon Cheechoo was photographed with a shutter speed of 1/180 of a second. At that speed his head is steady (he's taking a shot) but the hands and the stick are moving rapidly. A similar principle applies in the shot below. The goalkeeper remains sharp, but the ball and sticks are blurred by rapid movement.

Peak moment

Every sport has its classic photographs. From the crunching tackle in football to the follow-through in golf, there are iconic moments that can be relied on to provide memorable images.

Take the shot

Golf is one of the easier sports to photograph. There are plenty of peak moments—the driving shot, the triumphant putt, the blast ouf of the bunker—but the movement of the players is more static and easier to predict. This is useful, as you will often need to shoot from long-range in the spectator's area.

One of the downsides of most digital cameras is that they have what we call "shutter lag"–that is, a slight delay between pressing the button and the picture actually being taken. It's important to practice shooting action with your camera so that you get to know what fraction of a second that delay is and learn to anticipate by the right amount.

A good knowledge of the sport that you are trying to capture is always useful. Equally useful is a knowledge of how that sport is usually shown on the sports pages of your favorite newspaper or magazine. Many sports have concentrated bursts of energy which give you only one frame to "get the shot," while others will have prolonged passages of action allowing you to have several attempts. Here are a few examples of each:

High jumper. The jumper is at the top of the arc for a fraction of a second, and this is the point at which those classic pictures are taken. You can pre-focus on the bar and compose your picture in anticipation because you know that is where the action will be. Each jumper will have only a limited number of attempts.

Baseball pitcher. You know that he is going to pitch from the mound and you know where his front foot will fall, so you can prefocus and get your composition sorted. Each pitcher will be doing it many times in a single game, so you have more than one go at getting it right.

Swimmer. Only on the diving board is the swimmer still. Otherwise they are moving through the water at speed. You can compose and focus as you follow their progress, or prefocus on a given point on each length of the pool. Whichever way you shoot the swimmer, there will be more than one chance. Head-on from the end of the lane can produce striking images, particularly when the swimmer surfaces, as in the butterfly stroke.

Soccer player. It's almost impossible to prefocus on action in which there is a ball involved in the game. The direction of play switches very quickly and players will cross in between you and the action blocking your shot. The game lasts for a long time, however, and you will get many opportunities to get a good shot. Concentrate on following the ball, working the zoom control (if you have a zoom lens) to maintain the framing of players around it.

Where you position yourself usually dictates the shot that you are likely to get. Head-on to the action is often more dramatic, but makes focussing even more critical. It's a good idea to watch where professional photographers situate themselves for each sport, so that you get a good idea of the angles that work most effectively.

The lenses that you choose will have a dramatic effect on what you shoot as well. Getting tighter crops from a set position, foreshortening, and shallow depths of field are the three main reasons most sports photographers shoot the majority of the time with telephoto and super-telephoto lenses. Capturing action pictures is all about practice, planning, and anticipation.

A cautionary tale

Sometimes there are rules about when you can and cannot press the shutter, illustrated by the actions of one top golfing caddie who threw an amateur photographer's equipment into a lake when he shot at the wrong point in his player's swing, causing the player to badly miss-hit the ball. In sports where silence is required, the sound of even the quietest camera or the sight of a single flash can be upsetting to the players. If your camera has a flash built in, make sure that you have the flash disabled if you are in any doubt about whether flash photography is permitted.

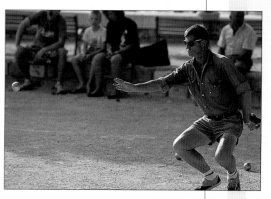

◄ Skiing
The best moments are those where the skier is moving at speed or, as here, up in the air with the powder spraying out behind. The difficulty is in getting close enough to the action without becoming part of it. The photographer took this from a safe vantage point, using a long lens with a fast shutter speed. The reflective snow and bright sun helped, giving plenty of light to work with.

▲ Boules
The French game of boules, played in a Provençal town park. in this sport, the moment is this: with the steel ball in midair and the player still in the throwing pose. It took a few tries before the position of the ball's image in the frame could be predicted and the right camera viewpoint chosen. The shutter speed needed to be moderately high at 1/250 second.

Freezing the action

Securing a crisply defined image of people in motion depends on a marriage of two kinds of technique: the capabilities of the camera and sensor, and your handling skills. Testing and feedback are the keys.

People move. This is an unavoidable fact of life in portrait photography, even when you pose them sitting. Minimum shutter speed always needs to be in the back of your mind unless you are relying totally on flash; and when movement is an integral part of the picture, as it is in sports, for example, then the correct shutter speed is critical.

The unquestioned assumption here is that the image needs to be sharp, and this is a reasonable assumption. There are exceptions, however, and we'll come to them on the following pages, but such motion-blurred images are special cases making distinct points and are in the minority.

We are dealing here with subject motion, but what is important to remember is that what matters is the movement within the picture frame and not the absolute movement.

Digital scores massively here, for two reasons. One advantage is that you can switch to whatever sensitivity is necessary in order to maintain the minimum shutter speed—and you can do this between one frame and the

Javelin
Shot for the book *One Digital Day*, which celebrated the many uses of digital technology around the world, the subject of this photograph was an experiment to track the velocity of a thrown javelin. As the situation was set up for the photograph, the throw could be repeated until the image looked right. Experiment showed that 1/500 second was sufficient, and out of many frames, this position and stance was judged the most successful.

next. The other advantage of digital is that you can check to make sure that the movement actually has been frozen (zoom in on the LCD display in order to do this).

To take full advantage of digital's capabilities for checking results, try at all costs to make at least one test shot. Obviously this is easiest in repetitive sports like horse trials and field events in which different competitors perform the same action.

Shooting mode

If the light is likely to change, these are occasions for using shutter-priority mode. This is particularly useful if the camera also has an Auto ISO option, which will automatically adjust the sensitivity to maintain the correct exposure at the set shutter speed.

Predictive tracking

Take advantage of whatever special methods your camera may offer to maintain sharp focus. Some models have a predictive option in which, once you have locked on to your subject, the focussing sensor will track the movement if he or she begins to move, even if that movement strays across the frame away from the original focussing zone.

Blur for effect

The impression of movement, rather than its strict factual details, may sometimes make for a more effective picture, but be prepared for unpredictability, surprises, and constant checking.

There is another, opposite treatment for people in motion and it is occasionally useful. Emphasis here is on "occasional," because individual portraits demand a certain recognizability, and that presupposes reasonable sharpness. Nevertheless, as long as there is a purpose to it, the techniques are fairly straightforward and revolve around long exposures to create streaking. What was once an unavoidable by-product of slow shutter speeds needed for dim lighting with slow film, and was seen as a fault, is now used deliberately to convey the sensation of time and movement, and also for graphic effect. Digital photography makes it possible to apply motion blur, as it is also called, with something approaching precision.

Instead of the minimum shutter speed being the baseline (*see the previous pages*), the idea here is to work with slower speeds which record the movement of a person as a noticeable blur. As in freezing the action, the actual speeds depend on how much movement you can see within the frame, but to work well visually, the blurring must be obvious. The small range of shutter speeds that almost give sharpness are of no use—the result will appear to be just a mistake. This is where the checking and feedback capabilities of a digital camera really come into their own. On automatic exposure, simply start with any speed slower than about 1/8 sec and examine the result on the LCD screen at magnification. The speed that works best is a matter of personal judgement; adjust the ISO sensitivity as necessary.

▼ **Bullfight**
The motion-stopping speed at a bullfight with a medium telephoto lens turned out to be 1/250 second for most of the time, but to introduce a significant blur, a speed of 1/2 second was used here. The intention was to convey the flow of action rather than its bloodier details.

If you keep the camera steady—for instance, by using a tripod—the streaking effect will come from people moving, and it is the combination of this and the sharp rendering of the surroundings that helps to make this kind of shot work.

Another possibility is to have your main subject keep still while surrounded by other people moving—again, a contrast of sharp and streaked. If you move the camera during a time exposure, everything will be streaked, normally a fault, but if you do this with a definite smooth movement, the impressionistic effect may be successful.

Finishing with flash

Slow synchronized flash can make a useful contribution to motion blur by superimposing a sharply rendered image on to the streaking. Experiment with the balance of time exposure and flash by adjusting the + or - compensation settings. With a focal plane shutter, as in an SLR, you may have the choice of front-curtain sync, in which the flash is triggered at the beginning of the exposure, and rear-curtain sync, in which the flash fires just before the end. Experiment with both syncs to see which effect appears the more satisfactory.

Panning

One special variant of motion blur is when you track a person moving across your field of view from one side to the other, and use a shutter speed that is just fast enough to keep the subject sharp. The result is a streaked background, which not only gives the impression of speed and direction but also helps to separate the person from the surroundings in a way similar to selective focus using a telephoto (see page 85).

◄ Monk on a bicycle
This shot of a monk being taken to a house ceremony in Cambodia was taken from a passing vehicle through the open window. By keeping the shutter quite slow at 1/30 second, the background was given a speed-streak blur, while the figures remain sharp.

▲ Architect
This portrait of a well-known Japanese architect was set up in a new subway station he had designed, with him leaning against one of his benches. To focus attention on him, he kept still while the shutter speed was set to one second (with the camera on a tripod).

▲ Shopping frenzy
The subject was this main branch of Marks & Spencer, one of the world's busiest stores. To emphasize this, the shutter speed was set at two seconds for a mixture of blur as some people examined merchandise while others walked by.

Performances

Whether you are shooting a mime artist in the street, a rock guitarist on stage, or a dress rehearsal of a world-class ballet company, you will need to exercise a combination of skills, while using only existing lighting.

The skills that a photographer needs to capture any performance borrow heavily from many other forms of photography. The sense of action and anticipation of a sports photographer, the available light abilities of a photojournalist, and the awareness of expression of a portraitist are all very useful when shooting any kind of performance. All performers know how to project an image to their audience, and everyone who watches them will unconsciously concentrate on a surprisingly small part of the scene at any one time. An actor might be on stage, surrounded by scenery and props, but as the audience we mentally zoom in on just the actor. Photographers need to mimic this mental cropping and compose their images so that there is enough of the scene to put the performer into some sort of context, but keep out any of the rest of the scene that doesn't add to the photograph. For example, the crop for a rock guitarist's solo would be a lot tighter than for a high lift at a ballet.

Young children on stage at a school production will often do the unpredictable, and it's these moments that make the most memorable pictures. When you are shooting these shows, you have to be very aware of not only the focus of the show, but also what the supporting cast is doing. Zoom lenses are extremely useful when shooting performances from the audience because they enable you to react to changes in composition when you cannot move yourself.

Using flash during the vast majority of performances is not permitted, so you have to work with the available lighting. Professional stage shows usually have well thought-out and atmospheric lighting that lets the photographer get good pictures, but even at these shows the level of the lighting can present problems, forcing you to compromise between using high ISO speeds and shooting with dangerously slow shutter speeds. Stage lighting is often high-contrast, so if your camera has a tone-control option, choose the low-contrast setting. Light metering when the stage lights are constantly changing is a headache, so using an automatic exposure mode can often be a good idea. At amateur performances and school shows, the lighting tends to be less dramatic and to change less frequently. This can help with

Burmese dance
A traditional Burmese dance/comedy known as *"pwe"* features a highly complex set of movements. From a distance of several meters with a sensitivity of only ISO 200, it was possible to maintain some of the ambience by shooting at 1/30 second with rear-curtain flash.

light metering, but once again you will probably face a choice between high ISO speeds or slow shutter speeds.

It is sometimes possible to shoot your pictures during a dress rehearsal rather than the performance itself. If you are in contact with the producers of the show, it's always worth exploring this idea. Once the rehearsal is over, there might be time to go back and restage important scenes. If you have shots of the scene you want to go back to, it can be a good idea to show the director and performers the shots on your LCD screen and explain how you want to set up the scene for photography.

Setting a digital camera's white balance for stage photography also presents challenges. Automatic white balances can easily be fooled when there are contrasty spotlights, so it is a good idea to select the white balance manually if you can. Most stage lights are either HMI or tungsten balanced and the difference between the two is hard to see with the naked eye. A few test frames should give you a good idea from the camera's LCD screen whether a daylight or tungsten preset balance would be best, or Auto, although a custom white balance is the best option if at all possible.

Street and outdoor performances present fewer lighting problems, although they often make composition harder because they may have messier backgrounds. As long as you remember to crop out as much of the scene as you can without destroying the all-important context, then outdoor performances often make great photographs.

Sitar and tabla
Musicians in the open-air courtyard of a hotel in Jaipur perform for dinner guests. It was shot at ISO 400, tungsten lighting was added from left and right to supplement the weak stage lighting.

Yoga display
A yoga master in Rishikesh, northern India, demonstrates some classic postures, here the Warrior, in a planned setting for the camera. The location is an old music pavilion in the grounds of a palace, and the photography was timed for sunrise, which had been recce'd the previous day. Planning meant that it was possible to make the most dramatic use of the light.

Picture essay

This famous tradition of feature photojournalism, established by the earliest picture magazines, aims to present a personal, extended view of a subject in the form of a set of images that tell a story.

One of the great editorial inventions, which is usually attributed to *Life* magazine but in actual fact dates to the 1930s, is the picture essay. The art director of the magazine *Weekly Illustrated*, Stefan Lorant, was the person who was primarily responsible for laying out combinations of photographs in such a way that they made a single graphic entity—such as a main shot that was supported by a strip of smaller images in a sequence.

At the time, this represented an entirely new way of presenting photography. It introduced a narrative element—a storyline—and created a justification for using several different pictures of the same subject or on the same theme. Used in conjunction with portraits, it became a powerful tool of magazine publishing.

Most important for photography is that the format of a picture essay induces a fresh way of thinking about a shoot, one in which the photographer is encouraged to see the totality of the session—which may be very extended, over a much longer period than one day. This in turn means planning for a series of pictures and being able to imagine, during shooting, how they might enhance each other, what juxtapositions of which images will work best, and how they can be ordered. In still-image form, this is much the same procedure as in documentary film-making and video.

Although the picture essay was first designed for illustrated magazines (and is still used in this way), it works perfectly well in other media that are more useful and available to individual photographers. These include a sequence of prints in an album, groups of images laid out digitally and printed on a single sheet of paper, groups of images on a web page, and on-screen slide shows.

Very few picture essays can stand alone without captions or an introductory text. This is not a weakness, and should not be confused with the common art gallery practice of hanging prints with minimal captions or none at all. A picture essay is a form of reportage, telling a story, and that story needs to be made clear.

Elements of a picture essay

☐ Theme
☐ Narrative flow
☐ Captions
☐ Large vs small
☐ Juxtapositions
☐ Visual variety

▲◄▼ A working life on the canals

Britain's canal system, once the transport infrastructure that enabled the Industrial Revolution, has survived only because of its leisure potential, as thousands of owners of narrowboats (as the traditional craft are called) use it for leisurely holidays. One of very few people who actually earn a traditional living from their boat is Ivor Batchelor, delivering fuel up and down the canals (with the help of a mobile phone and a good sense of humor).

Case study: **Picture essay**

The picture essay can also cover a wider subject than a single individual. In this example, several shots taken for a magazine article become an intriguing study of a group at work.

These photographs were culled from a larger selection shot as a picture story for a wildlife magazine. The story is about the day-to-day running of a small, independent animal hospital set up in Buckinghamshire, England, to cope with the accidents and illnesses suffered by local wildlife attempting to survive in an increasingly developed countryside. Injuries to animals involved in road and rail accidents or which have been abandoned and trapped, form the basis of the hospital's activities.

The story is an example of a small, tightly focussed magazine feature. Given that no more than about eight photographs would be used by the magazine on this kind of story, it was important to show both variety (of image and situation) and action. Hence these pictures cover the range from regular schedules (feeding and inspection) to emergency call-outs.

Because there is a story-telling component to reportage photography, it lends itself particularly well to a set of pictures covering a common theme. In professional magazine photography, this approach has been refined into the picture essay, which tells the story through a number of juxtaposed photographs, not necessarily in sequence. Depth of coverage is important—getting under the skin of the subject you are dealing with. Visually, though, it is also important to have variety in the finally selected set of images.

Emergency call-out
Rail staff had reported a muntjac deer struck by a passing express on a railroad. The ambulance crew use stretcher and blindfold to take the injured animal back to the hospital.

Constant monitoring
A veterinary nurse checks the cards in the hospital's intensive care unit for hedgehogs.

Bandaging
A wounded adult hedgehog receives urgent medical attention from the vet.

On the operation table
A badger with a broken pelvis as a result of a car accident is prepared for surgery.

Focussing on detail
Feeding an abandoned baby hedgehog by means of a syringe.

Glossary

aperture The opening behind the camera lens through which light passes on its way to the CCD.

artifact/artefact A flaw in a digital image.

backlighting The result of shooting with a light source, natural or artificial, behind the subject to create a silhouette or rim-lighting effect.

bit (binary digit) The smallest data unit of binary computing, being a single 1 or 0. Eight bits make up one byte.

bit-depth The number of bits of color data for each pixel in a digital image. A photographic-quality image needs eight bits for each of the red, green and blue RGB color channels, making for an overall bit-depth of 24.

bracketing A method of ensuring a correctly exposed photography by taking three shots; one with the supposed correct exposure, one slightly underexposed, and one slightly overexposed.

brightness The level of light intensity. One of the three dimensions of color in the HSB color system. See also hue and saturation.

buffer Temporary storage space in a digital camera where a sequence of shots, taken in rapid succession, can be held before transfer to the memory card.

calibration The process of adjusting a device, such as a monitor, so that it works consistently with others, such as a scanners or printer.

CCD (Charge-Coupled Device) A tiny photocell used to convert light into an electronic signal. Used in densely packed arrays, CCDs are the recording medium in most digital cameras.

channel Part of an image as stored in the computer; similar to a layer. Commonly, a color image will have a channel allocated to each primary color (e.g. RGB) and sometimes one or more for a masks or other effects.

CMOS (Complementary Metal-Oxide Semiconductor) An alternative sensor technology to the CCD, CMOS chips are used in ultra-high resolution cameras from Canon and Kodak.

color temperature A way of describing the color differences in light, measured in kelvins and using a scale that ranges from dull red (1900K), through orange, to yellow, white and blue (10,000K).

compression Technique for reducing the amount of space that a file occupies, by removing redundant data.

contrast The range of tones across an image from bright highlights to dark shadows.

cropping The process of removing unwanted areas of an image, leaving behind the most significant elements.

depth of field The distance in front of and behind the point of focus in a photograph in which the scene remains in an acceptable sharp focus.

diffusion The scattering of light by a material, resulting in a softening of the light and of any shadows cast. Diffusion occurs in nature through mist and cloud-cover, and can also be simulated using diffusion sheets and soft-boxes.

edge lighting Light that hits the subject from behind and slightly to once side, creating flare or a bright "rim lighting" effect around the edges of the subject.

feathering In image-editing, the fading of the edge of a digital image or selection.

file format The method of writing and storing information (such as an image) in digital form. Formats commonly used for photographs include TIFF, BMP and JPEG.

fill-in flash A technique that uses the on-camera flash or an external flash in combination with natural or ambient light to reveal detail in the scene and reduce shadows.

extraction In image-editing, the process of creating a cut-out selection from one image for placement in another.

filter (1) A thin sheet of transparent material placed over a camera lens or light source to modify the quality or color of the light passing through. (2) A feature in an image-editing application that alters or transforms selected pixels for some kind of visual effect.

focal length The distance between the optical center of a lens and its point of focus when the lens is focused on infinity.

focal range The range over which a camera or lens is able to focus on a subject (for example, 0.5m to Infinity).

focus The optical state where the light rays converge on the film or CCD to produce the sharpest possible image.

fringe In image-editing, an unwanted border effect to a selection, where the pixels combine some of the colors inside the selection and some from the background.

f-stop The calibration of the aperture size of a photographic lens.

graduation The smooth blending of one tone or color into another, or from transparent to colored in a tint. A graduated lens filter, for instance, might be dark on one side, fading to clear at the other.

grayscale An image made up of a sequential series of 256 gray tones, covering the entire gamut between black and white.

haze The scattering of light by particles in the atmosphere, usually caused by fine dust, high humidity or pollution. Haze makes a scene paler with distance, and softens the hard edges of sunlight.

histogram A map of the distribution of tones in an image, arranged as a graph. The horizontal axis goes from the darkest tones to the lightest, while the vertical axis shows the number of pixels in that range.

hot-shoe An accessory fitting found on most digital and film SLR cameras and some high-end compact models, normally used to control an external flash unit.

HSB (Hue, Saturation and Brightness) The three dimensions of color, and the standard color model used to adjust color in many image-editing applications.

hue The pure color defined by position on the color spectrum; what is generally meant by "color" in lay terms.

ISO An international standard rating for film speed, with the film getting faster as the rating increases, producing a correct exposure with less light and/or a shorter exposure. However, higher speed film tends to produce more grain in the exposure, too.

lasso In image-editing, A tool used to draw an outline around an area of an image for the purposes of selection.

layer In image-editing, one level of an image file to which elements from the image can be transferred to allow them to be manipulated separately.

luminosity The brightness of a color, independent of the hue or saturation.

macro A mode offered by some lenses and cameras that enables the lens or camera to focus in extreme close-up.

mask In image-editing, a grayscale template that hides part of an image. One of the most important tools in editing an image, it is used to limit changes to a particular area or protect part of an image from alteration.

megapixel A rating of resolution for a digital camera, related to the number of pixels forming or output by the CMOS or CCD sensor. The higher the megapixel rating, the higher the resolution of images created by the camera.

midtone The parts of an image that are approximately average in tone, falling midway between the highlights and shadows.

monobloc An all-in-one flash unit with the controls and power supply built-in. Monoblocs can be synchronised together to create more elaborate lighting setups.

noise Random pattern of small spots on a digital image that are generally unwanted, caused by non-image-forming electrical signals.

pixel (PICture ELement) The smallest unit of a digital image – the square screen dots that make up a bitmapped picture. Each pixel carries a specific tone and color.

plug-in In image-editing, Software produced by a third party and intended to supplement a program's features or performance.

ppi (pixels-per-inch) A measure of resolution for a bitmapped image.

reflector An object or material used to bounce available light or studio lighting onto the subject, often softening and dispersing the light for a more attractive end result.

resampling Changing the resolution of an image either by removing pixels (lowering resolution) or adding them by interpolation (increasing resolution).

resolution The level of detail in a digial image, measured in pixels (e.g. 10248 by 768 pixels), lines-per-inch (on a monitor) or dots-per-inch (in a half-tone image, e.g. 1200 dpi).

RGB (Red, Green, Blue) The primary colors of the additive model, used in monitors and image-editing programs.

saturation The purity of a color, going from the lightest tint to the deepest, most saturated tone.

selection In image-editing, a part of an on-screen image that is chosen and defined by a border in preparation for manipulation or movement.

shutter The device inside a conventional camera which controls the length of time during which the film is exposed to light. Many digital cameras don't have a shutter, but the term is still used as shorthand to describe the electronic mechanism that controls the length of exposure for the CCD.

shutter speed The time the shutter (or electronic switch) leaves the CCD or film open to light during an exposure.

SLR (Single Lens Reflex) A camera which transmits the same image via a mirror to the film and viewfinder, ensuring that you get exactly what you see in terms of focus and composition.

snoot A tapered barrel attached to a lamp in order to concentrate the light emitted into a spotlight.

soft-box A studio lighting accessory consisting of a flexible box which attaches to a light source at one end and has a diffusion screen at the other, softening the light and any shadows cast by the subject.

spot meter A specialized light meter, or function of the camera light meter, that takes an exposure reading for a precise area of a scene.

telephoto A photographic lens with a long focal length that enables distant objects to be enlarged. The drawbacks include a limited depth of field and angle of view.

TTL (Through The Lens) Describes metering systems that use the light passing through the lens to evaluate exposure details.

white balance A digital camera control used to balance exposure and color settings for artificial lighting types.

zoom A camera lens with an adjustable focal length giving, in effect, a range of lenses in one. Drawbacks include a smaller maximum aperture and increased distortion over a prime lens (one with a fixed focal length).

Index

Acknowledgments

The Author would like to thank the following for all their assistance in the creation of this title:
Filmplus Ltd, Nikon UK, REALVIZ, and nikMultimedia

Useful Addresses

Adobe (Photoshop, Illustrator)
www.adobe.com

Agfa www.agfa.com

Alien Skin (Photoshop Plug-ins)
www.alienskin.com

Apple Computer www.apple.com

Corel (Photo-Paint, Draw, Linux)
www.corel.com

Digital camera information
www.dpreview.com

Epson www.epson.com

Extensis www.extensis.com

Formac www.formac.com

Fractal www.fractal.com

Fujifilm www.fujifilm.com

Hasselblad www.hasselblad.se

Hewlett-Packard www.hp.com

Iomega www.iomega.com

Kingston (memory) www.kingston.com

Kodak www.kodak.com

LaCie www.lacie.com

Lexmark www.lexmark.com

Linotype www.linotype.org

Luminos (paper and processes)
www.luminos.com

Macromedia (Director)
www.macromedia.com

Microsoft www.microsoft.com

Minolta www.minolta.com
www.minoltausa.com

Nikon www.nikon.com

Nixvue www.nixvue.com

Olympus
www.olympusamerica.com

Paintshop Pro www.jasc.com

Pantone www.pantone.com

Photographic information site
www.ephotozine.com

Photoshop tutorial sites
www.planetphotoshop.com
www.ultimate-photoshop.com

Polaroid www.polaroid.com

Qimage Pro
www.ddisoftware.com/qimage/

Ricoh www.ricoh-europe.com

Samsung www.samsung.com

Sanyo www.sanyo.co.jp

Shutterfly (Digital Prints via the web)
www.shutterfly.com

Sony www.sony.com

Sun Microsystems www.sun.com

Symantec www.symantec.com

Umax www.umax.com

Wacom (graphics tablets)
www.wacom.com